IMAGES
of America

PHOENIX'S
AHWATUKEE-FOOTHILLS

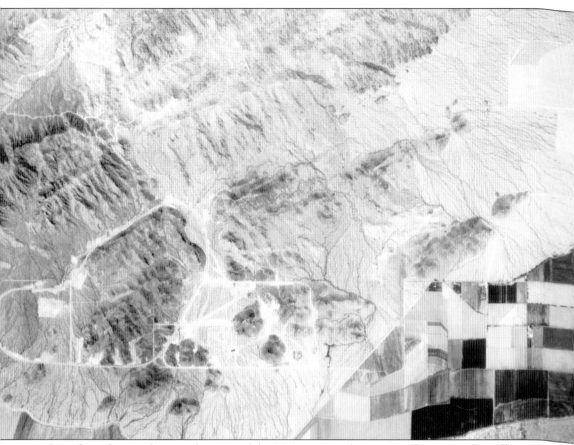

Seen from the air, this was the view of the 37.5 square-mile area now known as the Village of Ahwatukee Foothills in 1953. With South Mountain dominating the landscape (top), the area that became Ahwatukee lies to the mountain's east (the light-colored square and surrounding desert, top right). The future Mountain Park Ranch lies to Ahwatukee's southwest, with the land that became Lakewood south of that (the square farmland with the diagonal white line crossing its top left corner). Farther west, the future Foothills and Club West is the site of a heavy-equipment and motorized-truck proving grounds, easily distinguished by its elliptical test tracks. Just south of the proving grounds lies the Gila River Indian Reservation. There is no freeway, as construction of Interstate 10 was still over a decade away. Today the village made up of the five master-planned communities of Ahwatukee, Mountain Park Ranch, Lakewood, The Foothills, and Club West bears little resemblance to the rural, open-desert community that preceded it. (Courtesy Wisconsin Historical Society, No. 39937.)

ON THE COVER: Frank Lloyd Wright, accompanied by his wife, Olgivanna, stepdaughter Svetlana (dark shirt in back seat), and daughter Iovanna, is pictured in May 1929 in front of Camp Ocatillo near the southwestern border of what is now Mountain Park Ranch.

IMAGES
of America

PHOENIX'S
AHWATUKEE-FOOTHILLS

Martin W. Gibson

ARCADIA
PUBLISHING

Published by Arcadia Publishing
Charleston SC, Chicago IL, Portsmouth NH, San Francisco CA

Printed in the United States of America

Library of Congress Catalog Card Number: 2006926127

For all general information contact Arcadia Publishing at:
Telephone 843-853-2070
Fax 843-853-0044
E-mail sales@arcadiapublishing.com
For customer service and orders:
Toll-Free 1-888-313-2665

Visit us on the Internet at www.arcadiapublishing.com

*To my parents, Martin and Patricia Gibson, who always lead
their children by example and whose inspiration was the silent force
behind this book.*

CONTENTS

ACKNOWLEDGMENTS

In an area with no historical society, museum, or record repository, where does one go to learn its history? If the records of the company that developed Ahwatukee no longer exist, having been discarded long ago, then what hope is there to learn of how we arrived where we are today? Where does one begin to look?

In my case, it was with many of the people who had a hand in shaping the area's history. Only through the graciousness of many individuals is a book like this possible, and I am privileged to have been the recipient of countless acts of boundless generosity.

Individuals and institutions to whom I am indebted include Archaeological Consulting Service's Margerie Green; Arizona Department of Transportation's Doug Nintzel and Stuart Chase; the Chandler Historical Society's Nate Meyers; Landiscor's Nora Hannah and Jennifer Kellerman; Taliesin West's Margo Stipe and Bruce Pfeiffer; the Wisconsin Historical Society's Lee Grady, Andy Kraushaar, and Marguerite Moran; the *Ahwatukee Foothills News*'s Brian Johnson and Renie Scibona; and the Arizona Historical Foundation's Linda Whitaker, Susan Irwin, and Jared Jackson. My sincere gratitude goes to the foundation director, Jack August, for his invaluable mentoring and consistent guidance.

Thanks also to those voices on the telephone for their generosity to someone they haven't met, not even to this day, including Patty Artist, Ben Furlong, Alma Gates, Mike Longstreth, and Barbara Brinton Hackett. One individual in particular, Mike Foley, distinguished himself with his consistent insight, graciousness, and tenaciousness. I hope to one day have the opportunity to thank each one of these individuals in person.

Deserving of special thanks are those who invited me into their living rooms, kitchens, dens, and offices as they shared their recollections of days past. Posthumously Eli Gates and Marion Vance are fondly remembered. And I will be forever indebted to Art Brooks, Elaine and Jim Burgess, Carolina Butler, Tom Carney, Chad Chadderton, Sal DiCiccio, Evelyn Dye, Helen and Dick Evans, Grady Gammage Jr., Lois and Joe Garner, Melainie Gates, Phyllis Gates, Bruce Gillam, Ruth and Jim Goldman, Tom Kirk, Joe LeChaix, Susan and Ronnie Livingston, Kathy Martin, Dick McKenna, Pete Meier, Bill Montgomery, Hazel and Tom Owens, Jack Owens, Thelma Poitras, Randall Presley, Sheila Pruitt, Judy and John Ratliff, Rick Savagian, Clay Schad, Charles Schiffner, A. Wayne Smith, Jim Spadafore, Tom and Mike Vance, Lew Wilmot, and Beverly and Bill Woodmansee. Not all of their stories could be printed, but their enthusiasm and encouragement always kept me going!

Finally thanks to my wife, Angel, and son Matthew for enduring a seemingly never-ending series of interviews, research projects, and midnight writing sessions. My appreciation, too seldom expressed, for their understanding, patience, and support, recognizes the invaluable role they played in my completion of this book.

INTRODUCTION

It was 1970 when I first saw the 2,720 acres that were to become Ahwatukee. There were a few irrigated fields, an old abandoned ranch, and caretaker's house on the land—and that was it. No community of any kind existed on the south side of South Mountain. I had been told that local farmers viewed the area as a no-man's-land, since its only sources of water were a few isolated wells. There appeared to be little prospect of that changing.

But I saw something else. There was breathtaking natural beauty in the foothills of South Mountain. There was easy access to a major freeway. The land's proximity to Arizona State University and Phoenix hospitals would likely be attractive characteristics to retirees. And there were natural boundaries that I believed, under the right circumstances, could give the area a unique appeal and sense of community.

It is one thing to develop land that extends from an existing community but quite another to do so where no adjoining town or city exists. My first venture in real estate in 1946 involved the purchase and subdivision of a three-acre strip of land in Bakersfield, California, into 12 houses. Those homes sold quickly because they were a natural extension of an existing community.

In the late 1960s, my company conducted a demographic study of every city west of the Mississippi River with a population of at least one million people. No such study was done for Phoenix. I was familiar with and had always liked the area since my Army Air Corps pilot-training days at Thunderbird Air Field during World War II. By the time the Presley Companies moved into the Phoenix market in 1969, we had built thousands of homes in California. I was intimately familiar with the Southern California market, where I had done progressively larger projects throughout the years, and was seeking to expand the company's operations into Arizona.

My first two developments in Phoenix, on the west side of town, were natural extensions of existing neighborhoods, communities, and population centers. Many purchasers were homeowners seeking to move up from existing developments. People knew the area.

But these were ready-made subdivisions. Civilization was already close by. The same could not be said at the time about the land south of South Mountain and west of Interstate 10. Nothing existed resembling an infrastructure with which to bring in water, if one could get it, and basic utilities. The area at the time was considered remote. It is no exaggeration to say that I drove back and forth on that freeway 30 to 40 times over a period of one month, sizing up the property and trying to decide whether anyone would want to live there. I asked myself, from a buyer's perspective, "Would I go all the way out there looking for a house?" Ultimately I decided that I would, if the area held enough attraction to make it interesting.

Ahwatukee was initially conceived as a golf course community primarily for retirees. But with 2,080 acres (to which we later added 640 acres right at the foot of South Mountain), I did not want to rely on only one segment of the market. I decided to offer retirement living inside a circular thoroughfare and adult and family living outside the [Warner-Elliot] loop, which would serve to keep major traffic off residential streets.

Given its relative isolation I expected a slow start for Ahwatukee—and got it. I was confident that once people saw the area they would like it and realized that I had to do something creative to bring in prospective buyers. The singer Tennessee Ernie Ford and I had been members of the same squadron in the Air Corps during World War II, so I enlisted him to do a series of radio advertisements for Ahwatukee. That and newspaper ads increased traffic and sales.

Early consideration was given to converting the old abandoned ranch house one and a half miles from the freeway into an historical attraction or visitor center, but that was not feasible because the house was in such disrepair. Eventually the concept decided upon was that of a home

to serve as a demonstration of futuristic living while attracting visitors to and showcasing the new community. I approached the Frank Lloyd Wright Foundation with my idea for a House of the Future. Between 1980 and 1984, some 250,000 people toured the house and in the process got a good look at the fledgling community of Ahwatukee. Many became homeowners there.

The success of Ahwatukee was due in great part to the efforts of two individuals. The first manager of the project, Dan Verska, and his successor, Bruce Gillam, are two of the most capable people with whom I have had the pleasure of working. Their efforts played a major role in Ahwatukee's success.

With the steady growth of sales in Ahwatukee, the master-planned communities of Mountain Park Ranch, Lakewood, The Foothills, and Club West developed in the 1980s and 1990s. But by then, the area had the infrastructure to support growth and was no longer the remote curiosity it had once been, as a result of Ahwatukee having paved the way.

Ahwatukee was the riskiest project of my career. No one had ever built on the south side of South Mountain, which had always been a natural dividing point with the city of Phoenix. There was no water, no utilities, and no guarantee that I could get either. But the beauty, accessibility, and potential of the area convinced me that it was worth the risk, and I proceeded on a little bit of faith that things would work out.

As this book illustrates, things did work out, not only for Ahwatukee but for those master-planned communities that followed. Marty Gibson's meticulous research illustrates for us in words and photographs what the community was like prior to development and how it evolved and grew over time. The images in this book are important historical records in their own right but all the more significant for having been brought together here for the first time. Collectively they illustrate the history of a very special community.

It is truly amazing to consider what a rich history Ahwatukee-Foothills has and how dramatically the area has changed over time. I am both proud and honored to have played a role in its development.

—Randall Presley
June 2006

Randall Presley is semiretired and living in Newport Beach, California.

One

SETTLERS AND WATER

The country's wild and at-times inhospitable West had been tamed to a degree a thousand years ago by the Hohokum. But it took an act of government to encourage systematic settlement after the Civil War. Each settler under the Homestead Act was required to establish a residence in a structure of not less than 12 by 14 feet and to farm a certain percentage of his or her land. The canals from which farmers brought water to their lands were fed by the Salt River, originating in eastern Arizona and flowing southwest year-round through Phoenix. Farming could be very good when Mother Nature cooperated, but crops were often wiped out when flooding or drought occurred. The construction of Roosevelt Dam brought much-needed stability to the Salt River Valley and gave birth to a series of farms along a main canal that ran through part of the future Ahwatukee Foothills.

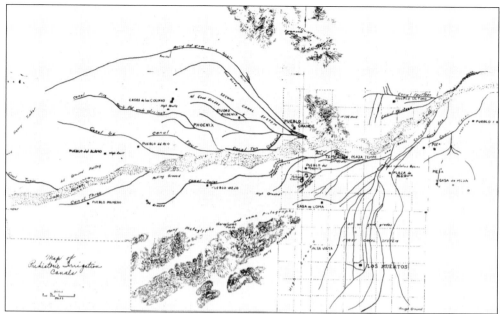

The Hohokum were skilled farmers who harnessed the life-giving waters of the Salt River through an elaborate series of irrigation canals. Dug by hand, the largest of these canals measured 35 feet wide and 10 feet deep. This map of the Salt River Valley's prehistoric canal system shows the Salt River crossing the middle of the map with today's South Mountain, then the Salt River Mountains, at bottom center. Significantly, the future Ahwatukee area (right of the mountain) is designated as "high ground." (Courtesy Arizona Historical Foundation.)

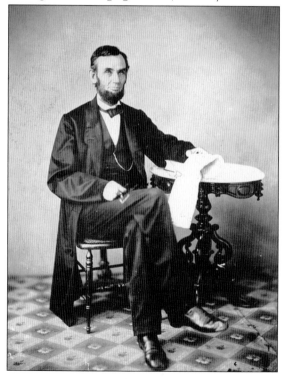

In order to encourage settlement of the American West, the Homestead Act was signed into law by Pres. Abraham Lincoln in 1862. The act provided undeveloped land, typically 160 acres, to any settler willing to make certain improvements to it. Some of the first families in what became the Kyrene farming community and Ahwatukee-Foothills came to the area based on the prospect of owning land under the Homestead Act. (Courtesy Arizona Historical Foundation.)

Early Homestead Act settlers had to be hardy, resourceful, and extremely self-sufficient in order to survive. Their typical house was small, cramped, and self-built, with farmland cleared and cultivated using improvised tools. Slowly many homesteaders capitalized on their pioneering spirit to create a hardy, but relatively contented, life for themselves and their families. (Courtesy Arizona Historical Foundation.)

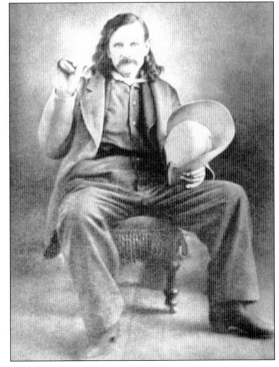

Jack Swilling, often referred to as "The Father of Phoenix," arrived in the Salt River Valley in 1867. Recognizing the potential of the ancient Hohokum canals, he and several partners reconstructed part of the network to facilitate irrigated farming and in doing so gave rise to what became the city of Phoenix. This famous photograph of Swilling was taken in 1870 when he was 40 years old. (Courtesy Arizona Historical Foundation.)

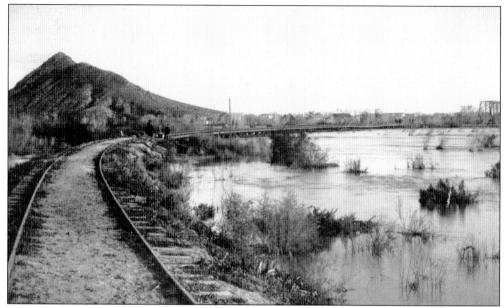

During periods of abundant rainfall and heavy snowmelt in the mountains, the Salt River often overflowed its banks and flooding occurred. Conversely, summer months typically saw the water level very low and crops in their greatest need for water. This cycle of feast-or-famine is illustrated in this 1891 photograph of winter flooding on the banks of the Salt River in Tempe. (Courtesy Arizona Historical Foundation.)

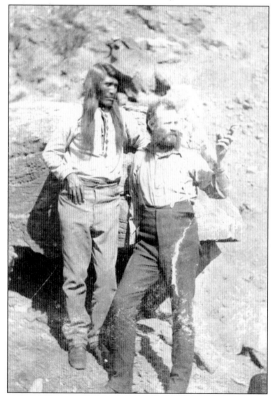

Settlers in the valley realized that a water-management system was needed to tame the Salt River. Civil War veteran John Wesley Powell, who lost his right arm during the war, had a profound influence on and was a major force behind the concept of reclamation, or the reclaiming of the arid desert. Here Powell is seen with Paiute Indian chief Paw-Gu in southern Utah in 1874. (Courtesy Arizona Historical Foundation.)

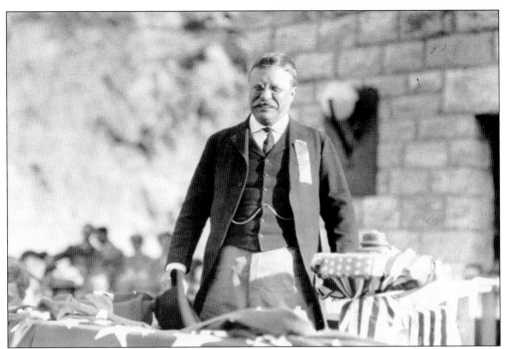

The National Reclamation Act, which set aside money from the sale of public lands for the support of reclamation projects in the West, was signed into law by president and reclamation-proponent Theodore Roosevelt in 1902. Sponsored by representative Francis Newlands of Nevada, the act was a major turning point in the development of the West in general and Salt River Valley in particular. (Courtesy Arizona Historical Foundation.)

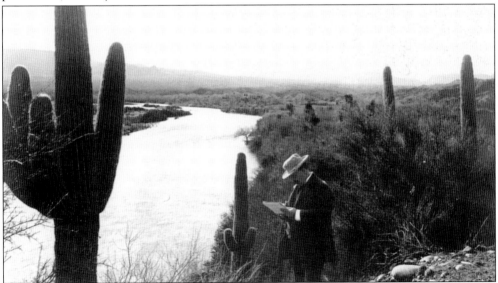

The first major project of the newly created United States Reclamation Service was Roosevelt Dam, located at the confluence of Tonto Creek and the Salt River about 80 miles northeast of Phoenix. Surveyors like this one, in an undated photograph, found the site's wide basin and high rock walls ideal for creation of a storage reservoir from which canals could transport water to the Salt River Valley. (Courtesy Arizona Historical Foundation.)

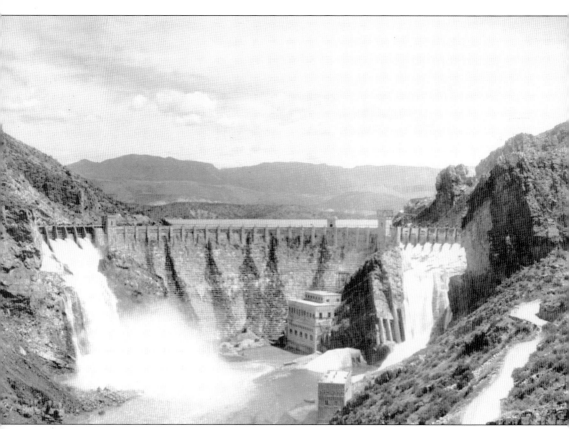

Salt River Valley landowners knew they had to work together to create a water-management system that would bring consistency to their farming efforts and enable them to "reclaim" the arid desert for agricultural use. Roosevelt Dam was the answer, and to pay for it, 4,800 landowners in the Salt River Valley were organized under the Salt River Valley Water Users' Association. Their land, totaling 248,000 acres, was pledged as collateral in order to receive federal funding for the dam. Early construction involved the improvement of 64 miles of an old Indian road, the Apache Trail, so that construction materials could be transported to the dam site. Completed at a cost of $12 million, the dam was dedicated on March 18, 1911, with namesake Theodore Roosevelt among the ceremonial speakers. Many consider Roosevelt Dam's construction to be the single most important milestone in Arizona's history. The Arizona Territory became a state the following year, and the farmers' mortgage to the federal government was paid in full by 1955. (Courtesy Arizona Historical Foundation.)

Two

KYRENE FARMING COMMUNITY

As in much of the country during the first half of the 20th century, school, church, and agriculture were the ties that bound the loose patchwork of farm families living in the future Ahwatukee Foothills. But unlike in much of the country, the very existence of these farmers depended on a controlled version of Mother Nature in the form of the Highline Canal in the future Ahwatukee Foothills area and the Kyrene and Western Canals farther east. Beginning with the earliest homesteaders, members of the Kyrene farming community worked hard yet found ways to incorporate leisure that were linked to the land on which they lived. The Gates family's dairy was the second largest in the state during the mid-1950s and was also the site of the first non-canal swimming hole in, and for, the community.

Long before there was an Interstate 10, the area bordered on the east by Price Road, north by Guadalupe Road, west by Thirty-second Street to just north of South Mountain, and south by the Gila River Indian Reservation was known as the Kyrene farming community. So named because it was served by the Kyrene School, initially at the intersection of McClintock and Warner Roads from 1880 to 1920 and then on the northwest corner of Kyrene and Warner Roads, the community was a loose-knit collection of farm families whose lives and livelihoods depended on water from the Highline, Kyrene, and Wesern Canals. The Highline Canal (the curved line from the top to the left) was a result of the Salt River Project's Roosevelt Dam and ran southwest from below Guadalupe Drive before it curved near West Chandler Road (today Chandler Boulevard) and ended at Fortieth Street. Lines designating square-mile sections of land are clearly visible in this 1949 view of Ray Road (crossing the top) and West Chandler Road (crossing the lower middle). There is no freeway, but splitting the middle of the photograph vertically is the Forty-eighth Street alignment. (Courtesy Salt River Project Research Archives.)

The teachers at Kyrene School taught the children of the area's farmers and ranchers in the days before development and master-planned communities created the need for 26 schools in the Kyrene School District. This undated photograph of one of four classrooms on the tiny campus shows the school's bell mounted on the roof. Today the bell that summoned generations of Kyrene students to class is displayed in the lobby of Kyrene's administration building on the site. (Courtesy Kyrene School District.)

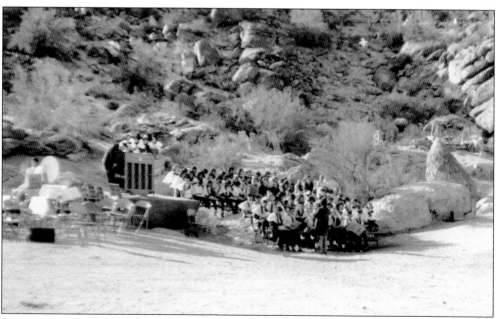

For years, the foothills of South Mountain served as the setting for Kyrene's annual Christmas pageant. In this December 1964 photograph, teacher Catherine Rubush (with back to photographer) leads a recital by the Kyrene choir, in the desert and complete with piano, near today's Ahwatukee Custom Estates area. Earlier pageants included donkeys as part of nativity scenes until one got loose, wandered up South Mountain, and precipitated a largely futile chase by a number of pageant participants. (Courtesy Kyrene School District.)

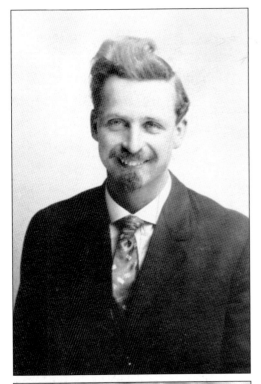

Their street names are familiar, but less well known is the fact that each of these men got his start homesteading in the Kyrene area in the early years of the 20th century. Reginald Elliott, above, was born in California in 1887, came to Arizona in 1914, and homesteaded 160 acres on the southeast corner of today's Priest Drive and Elliot Road, the current home of Sports Authority Plaza.

An error in the naming of Elliot Road accounts for the different spellings of the family and roadway names. Samuel Warner, a Kansas native born in 1866, arrived in the Arizona Territory in 1908 and homesteaded 160 acres on the southeast corner of today's Priest Drive and Warner Road, currently home to the Warner Business Park. Neither would recognize his surroundings today. Buried in Tempe's Double Butte Cemetery, their final resting place lies in close proximity to the rush of Interstate 10, its infamous Broadway curve, and The Buttes resort. (Both courtesy Owens family.)

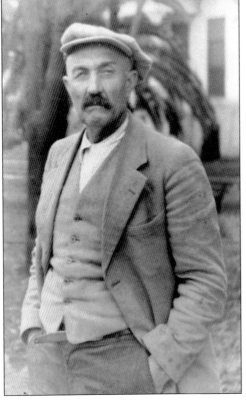

Born in 1888, Arthur Hunter homesteaded 160 acres on a dirt lane between what is now Thistle Landing and Chandler Boulevard. With a mule pulling an old, spiked railroad tie, Hunter cleared the land and built the house where he and his wife raised eight children. Seen here around 1913 with his mother, daughter Louise, and son Leslie (who he is holding), the 25-year-old Hunter lived and farmed on Hunter Drive, known today by its more familiar name of Forty-eighth Street. (Courtesy Lois and Joseph Garner.)

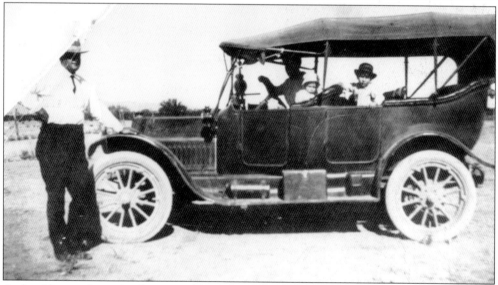

Arthur Hunter claimed to have purchased this 1916 Studebaker, used and complete with bullet holes, from Chicago mobster Al Capone. Like other Midwesterners, Capone was a snowbird and rumored to have laid low in the Phoenix vicinity during the winters of the 1920s. Hunter, pictured here in the late 1920s with, from left to right, Mollie and youngest children Mildred and Joe, tooled around the Kyrene farming community in the vehicle until the early 1940s. (Courtesy Lois and Joseph Garner.)

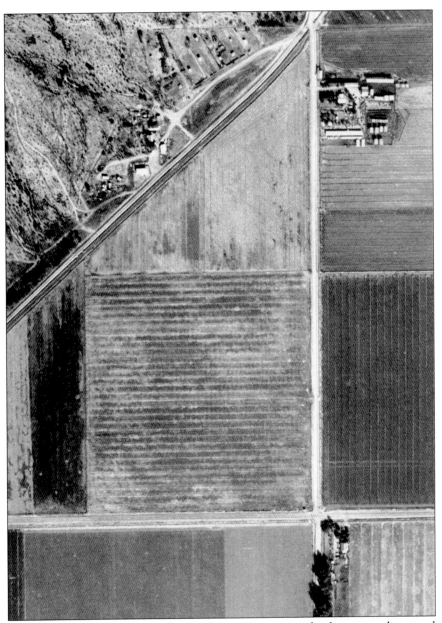

Named for the homesteading Hunter family, Hunter Drive was a dirt lane extending north from the Gila River Indian Reservation to Warner Road. In this early 1970s north-south view, the Hunter house and ranch buildings are seen in the upper part of the photograph on both sides of the Highline Canal, with the Bill Gates house and outbuildings, at bottom, on the southeast corner of Williams Field Road. Gates farmed the 40 acres on the west side of Hunter Drive (center), Arthur Hunter the triangular pieces on either side of Gates, and Dick Evans the 40 acres on the northeast corner of Hunter Drive and Williams Field Road (east of Gates). Today Hunter Drive is known as Forty-eighth Street, Williams Field Road as East Chandler Boulevard, and the intersection at lower right as home to, among others, a Hooters restaurant. (Courtesy Lois and Joseph Garner.)

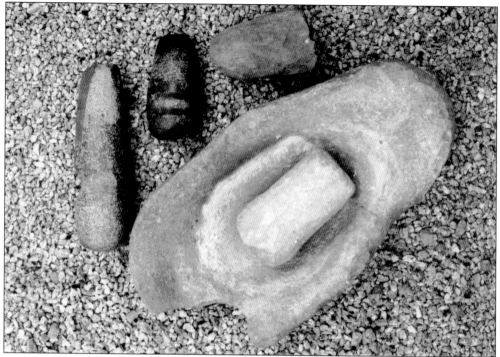

Owing to its "high ground" geography (page 10) due to its proximity to South Mountain and resultant water run-off, archaeological studies have not placed a great deal of Hohokum activity on the land that became Ahwatukee-Foothills. Nevertheless early farmers in the area routinely dug up primitive tools and implements when plowing their fields. These are but a few found over the years on the Owens farm, on Kyrene Road between Warner and Ray Roads. (Courtesy Owens family.)

Originally homesteaded by Jesse and Edna Padfield in 1915, the land on the southeast corner of what would eventually become Forty-eighth Street and Chandler Boulevard was purchased by the Gates family, descendents of another homesteader, in the mid-1940s. Growing mostly barley and alfalfa, and in partnership with his father, Herbert, and brother Eli, Bill Gates lived with his own family in this house a few hundred yards south of Williams Field Road. In this 1954 photograph, Hunter Drive runs diagonally in the lower right. (Courtesy Gates family.)

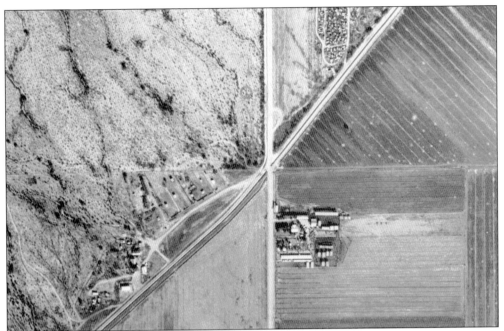

This photograph of the future intersection of Forty-eighth Street and Thistle Landing, *c.* early 1970s, illustrates the dramatic difference in land above and below the Highline Canal. The Hunter residence is surrounded by fertile farmland on the lower, or southeastern, side of the canal, with raw desert on one side of Hunter Drive and Eli Gates's former dairy (the triangular piece at top) on the other. (Courtesy Lois and Joseph Garner.)

With the shift from agriculture to residential and commercial, the Highline Canal flows largely underground today. Where once a small wooden bridge crossed over the canal on Hunter Drive, today the intersection of Forty-eighth Street and Thistle Landing bears little resemblance to its rural past. One relic, however, lives on as a reminder, in the form of a Salt River Project irrigation gate on the northeast corner of the intersection.

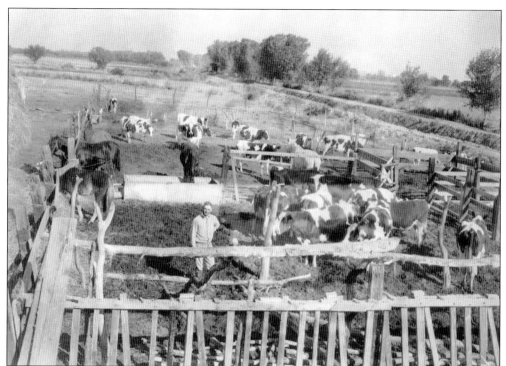

During World War I, Eli Fount Gates homesteaded 160 acres on the northwest corner of Highline Drive and Pima Road, which today is Fifty-sixth Street and Ray Road. His son Herbert started a dairy operation on land at the southeast corner of Hunter Drive and Pima Road, today's Forty-eighth Street and Ray Road. Herbert Gates is seen here in the early 1930s with the Highline Canal passing through the property at the upper right. (Courtesy Gates family.)

Third-generation Kyrene residents, Eli (left) and Bill Gates were born in their parents' house on the dairy in 1926 and 1928, respectively. Eli grew up to farm 120 acres at the southeast corner of Fifty-sixth Street and Ray Road, while Bill farmed 80 acres on Hunter Drive. The family worked together in the operation of the dairy. (Courtesy Gates family.)

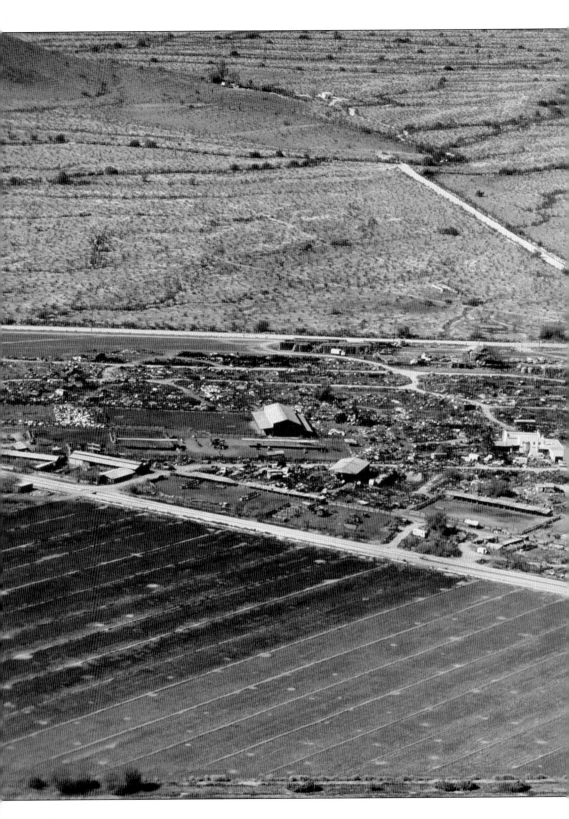

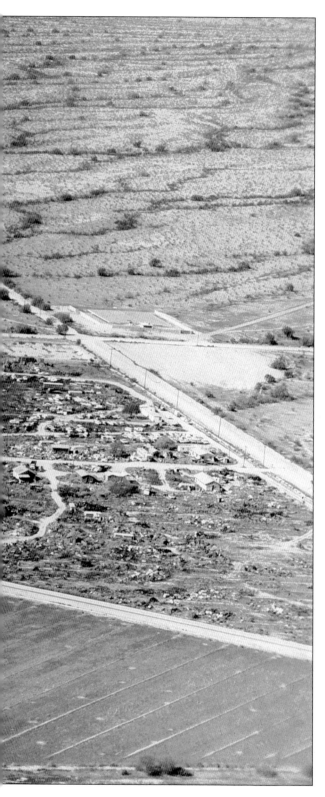

The intersection of Forty-eighth Street and Ray Road, looking northwest across the former Gates dairy, remains well preserved in this 1973 photograph. Entering from right to left, top to bottom, are Forty-eighth Street in the middle of the photograph, followed by Ray Road and the Highline Canal, which crosses the Gates's property. Named for a pioneering farm family in the Gilbert area, Ray Road's name was changed from Pima Road in the 1930s. Note that the dirt road dead ends about a quarter mile west of the intersection, with the Pima Ranch structures (see chapter seven) visible in the distance. The square structure on the northwest corner of the intersection is a newly built 1.5 million gallon water reservoir and lift station, precipitated by initial construction of Ahwatukee. Today the bustling intersection and surrounding area bears little resemblance and stands in stark contrast to this peaceful scene. (Courtesy Gates family.)

Like many in post-Depression America, residents in the Kyrene farming community made their own fun without the benefit of a lot of conveniences. During Arizona's hot summers, waterskiing on the canal was a popular way to beat the heat. Using spare wood and an old pair of shoes, Tom Carney cruises along at 35 miles an hour courtesy of a pickup truck on the canal bank. (Courtesy Thomas Carney.)

With the Highline Canal already on his land, Herbert Gates built what could be considered the very first among thousands of swimming pools to come in Ahwatukee-Foothills. Constructed in the early 1950s on the northwestern-most corner of his diary, this 110-foot-long, square, gunnite-lined irrigation water-holding pond also doubled as the beach for local residents. In this 1953 photograph, Eli Gates's wife, Melainie (right), swims with daughter Elaine as other bathers enjoy a refreshing dip. (Courtesy Gates family.)

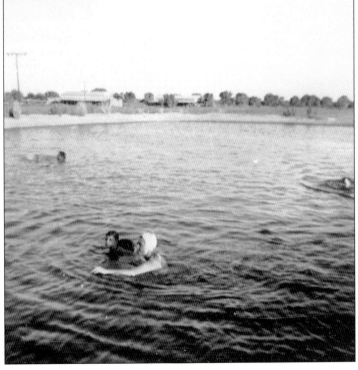

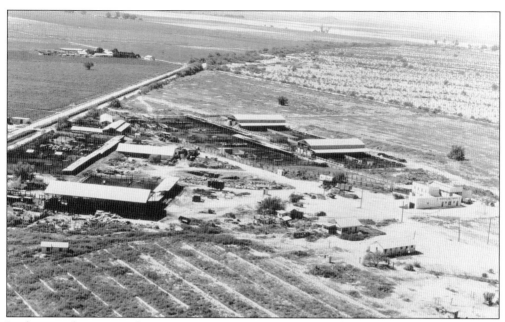

Looking southwest toward Hunter Drive and the future Forty-eighth Street (crossing the top from right to left), corrals, shade covers, and the main building (extreme right) are seen in this 1958 view over the Gates dairy. Arthur Hunter's house sits at top left of the photograph. The Highline Canal, entering the photograph at left, heads toward its point of termination at Fortieth Street and Chandler Boulevard near Earl Krepela's dairy. (Courtesy Gates family.)

Almost all of the crops in the Kyrene area after World War II were sprayed at one time or another by Sanders Aviation Company. Alfred "Rowd" Sanders started a crop-dusting business on 200 acres of raw desert on the northeast corner of Fifty-sixth Street and Elliot Road in the late 1940s. Sanders planted citrus groves surrounding his airport's half-mile-long dirt runway. Tempe's Grove Parkway was constructed on the site in 1985, and a Wal-Mart sits on the southwest corner of the property today. (Courtesy Susan and Ronnie Livingston.)

Today an AMC-24 movie theatre, a Barnes and Noble, and a host of retail establishments call this home. Back in 1994, the view along the south side of Ray Road east of Forty-eighth Street offered something quite different. This photograph of Eli Gates's property fronting Ray Road (above) captures some of the ambiance of the former dairy-turned-junkyard in June 1994. Looking north along Forty-eighth Street (below), the junkyard is seen as the final resting place for all sorts of machinery, large and small. When this photograph was taken in March 1995, the area was in transition. In the far distance, an era of increasing convenience for Ahwatukee-Foothills shoppers was dawning, as stores such as Target, Albertson's, and Michael's had recently opened on Ray Road. Once sold, it took almost a year to clear the property before any development could begin.

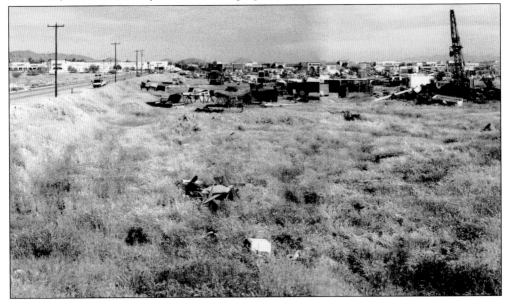

Three

SAN MARCOS
AND CAMP OCATILLO

The landscape in Ahwatukee Foothills might look very different today had the stock market not crashed in 1929. That was the year Dr. Alexander Chandler, builder of one of the first hotels in Arizona, took initial steps to realize his dream of constructing a resort hotel on 600 acres of land he owned near what ultimately became southwestern Mountain Park Ranch. At the time, the only activity in the area involved speakeasies rumored to be operating in the foothills north of what would eventually become The Foothills. Dr. Chandler's idea never came to fruition, but his influence on the area left its mark.

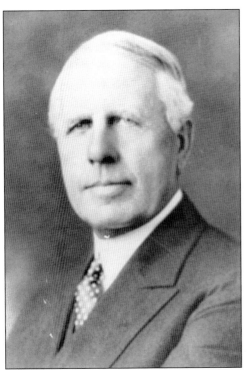

Alexander Chandler was born in Detroit in 1859 and became Arizona's first territorial veterinarian in 1887. He recognized the potential that the Sonoran Desert held when water was brought to it and acquired vast landholdings in the city that bears his name as well as in part of the area that eventually became Mountain Park Ranch and The Foothills. Dr. Chandler was 56 years old when he posed for this photograph in 1915. (Courtesy Chandler Historical Society.)

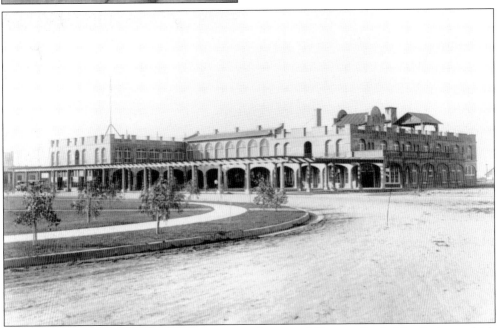

The San Marcos Hotel was the second resort in the state, following Castle Hot Springs, which debuted in 1896. The San Marcos attracted the rich and famous and as the first resort with a golf course played a major role in ushering in Arizona's tourism and golf industries. Given Dr. Chandler's landholdings, it also had a significant presence in the eventual Ahwatukee-Foothills area 10 miles to the west. This photograph of the resort was taken shortly after it opened on November 22, 1913. (Courtesy Chandler Historical Society.)

Among the wealthy San Marcos patrons seeking respite from harsh Midwestern winters was one who would end up making Arizona her permanent winter home and, in the process, give Ahwatukee its name. Helen Brinton, a native of Dixon, Illinois, spent several winters with her parents at the San Marcos Hotel in the 1920s and fell in love with the Sonoran Desert. She decided to make it her home and purchased the Mystic House (see chapter four) in 1935. Here Brinton is seen in her early 20s, c. 1895. (Courtesy Barbara Brinton Hackett.)

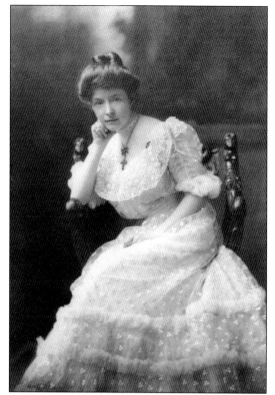

The unspoiled Sonoran Desert provided creative inspiration to many and particularly Dr. Chandler. He envisioned a resort that would surpass even his San Marcos Hotel, rising from the desert floor on land he owned adjacent to South Mountain. This undated photograph typifies the pristine view of native flora and fauna as one approached the area on the 10-mile drive west from the San Marcos. (Courtesy Chandler Historical Society.)

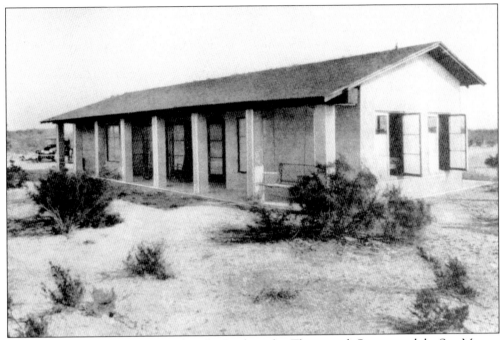

On the south side of what is now Chandler Boulevard at Thirty-sixth Street stood the San Marcos Desert Inn. Alternately known as the Desert Lodge, the small building served as a base camp for San Marcos Hotel guests to saddle up for horseback or hay rides into the desert, where they would barbeque or simply take in miles of scenic vistas. The poured-concrete structure was enlarged in 1942 and converted into his residence by Bill Collier, who farmed the area that became Lakewood until the mid-1980s. (Courtesy Chandler Historical Society.)

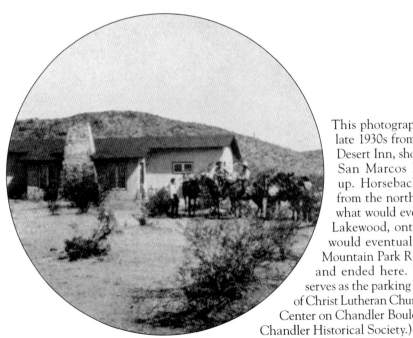

This photograph, taken in the late 1930s from the rear of the Desert Inn, shows guests of the San Marcos Hotel saddling up. Horseback and hayrides from the northernmost part of what would eventually become Lakewood, onto the land that would eventually become west Mountain Park Ranch, originated and ended here. Today this site serves as the parking lot of the Family of Christ Lutheran Church and Learning Center on Chandler Boulevard. (Courtesy Chandler Historical Society.)

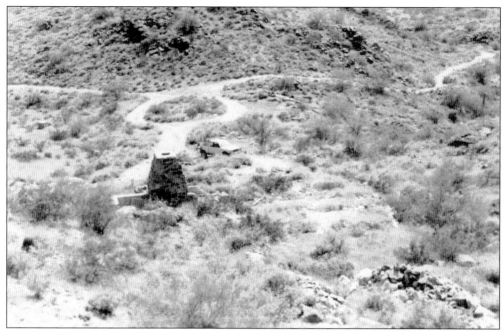

Two barbeque areas near the Desert Inn were constructed by the San Marcos Hotel for its guests. One, a short distance northwest of and closest to the lodge, was the more frequently used of the two and often featured a cowboy singer for entertainment. The second, requiring a climb up a long dirt drive, was high above the desert floor in the South Mountain foothills almost directly north of today's Thirty-second Street. These two photographs show the remains of the latter 10-foot-tall barbeque above in 1983, prior to development in the immediate area. The structure remains standing today, below, in a homeowner's backyard in Mountain Park Ranch. (Above courtesy Archaeological Consulting Services Limited.)

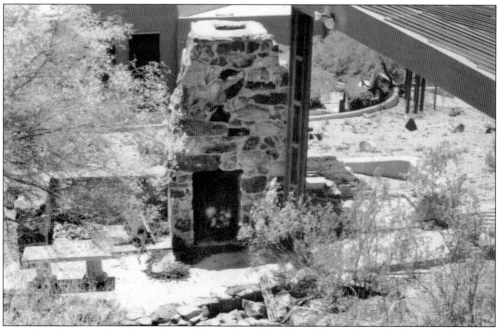

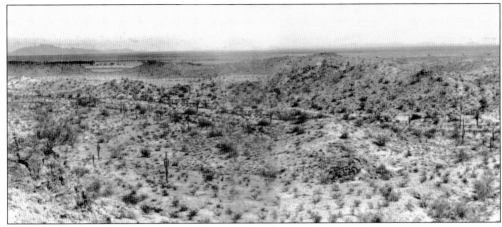

In the 1920s, Dr. Chandler organized the Chandler Improvement Company, which acquired vast land holdings in the area that eventually became Mountain Park Ranch and The Foothills. In 1928, Dr. Chandler hired renowned architect Frank Lloyd Wright to design a 300-room resort in its natural desert setting to rival Chandler's San Marcos Hotel. The 600-acre site, as seen in this 1929 photograph looking south, was just west of the intersection of present-day Chandler Boulevard and Thirty-second Street. (Courtesy Frank Lloyd Wright Archives, Taliesin West, Scottsdale.)

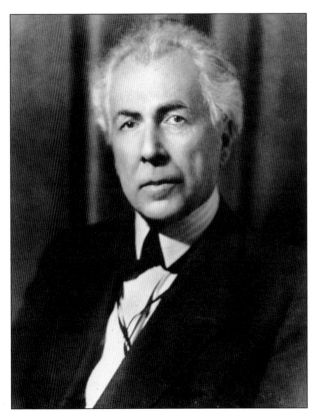

Frank Lloyd Wright was recognized as America's preeminent architect by the time he designed the textile block exterior of Phoenix's Arizona Biltmore Hotel in 1928. Dr. Chandler approached Wright about designing a desert resort incorporating the natural beauty of its surroundings that would be called San Marcos-In-The-Desert. Although never built, the resort served as the inspiration for Wright's Taliesin West in north Scottsdale. Wright is pictured here in 1930 at age 60. (Courtesy Frank Lloyd Wright Archives, Taliesin West, Scottsdale.)

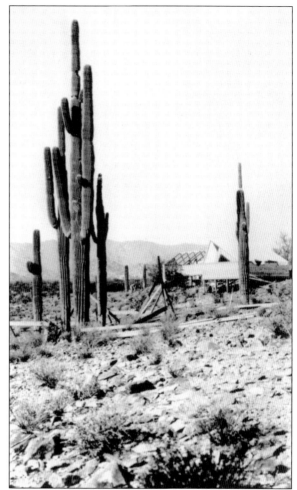

Fifteen people, including Mr. and Mrs. Wright, their two children, seven draftsmen, a cook, and a few servants, left Wisconsin for Arizona during a January 15, 1929, blizzard. Wright decided to build a temporary desert camp overlooking the resort site that would serve as both living and working quarters for the party. Camp Ocatillo was constructed on a knoll just south of the resort site and consisted of 15 cabins, each with its own stove, constructed in a wooden board and batten fashion with light canvas overhead and in place of glass windows. A continuous low wooden wall surrounded the entire camp. (Both courtesy Frank Lloyd Wright Archives, Taliesin West, Scottsdale.)

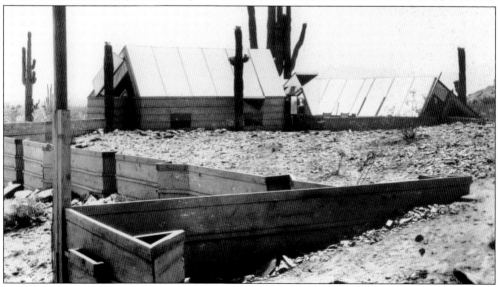

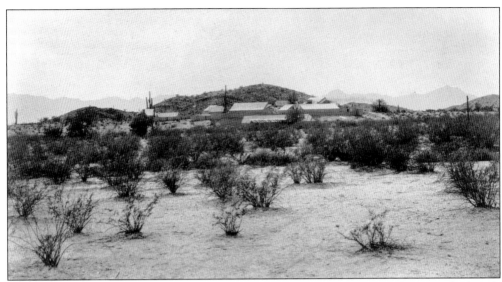

Because the knoll on which the campsite was constructed was uneven, the cabins were built with wooden floors slightly above ground. Wright believed that living at the campsite would be beneficial not only during the design phase, but it also could prove advantageous once construction of the resort started. (Courtesy Frank Lloyd Wright Archives, Taliesin West, Scottsdale.)

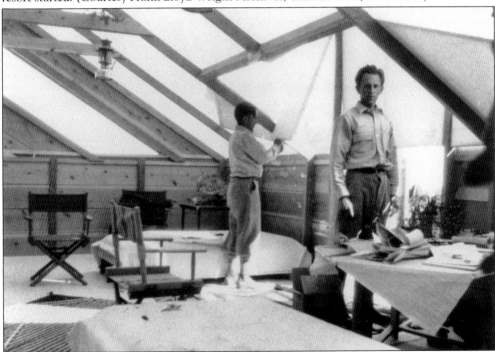

Two of Wright's draftsmen are seen inside one of the cabins. Henry Klumb, facing the camera, was a German-born architect who worked with Wright from 1929 to 1933. Vladimir Karfik, a native of Czechoslovakia who spent a little more than a year with Wright, stands by the bed. While the informality of camp life was peaceful, the relaxed mood quickly changed when the occasional rattlesnake slithered into camp. (Courtesy Frank Lloyd Wright Archives, Taliesin West, Scottsdale.)

Wright sought to create strong harmony between the prospective resort and its desert surroundings. Similar to the Arizona Biltmore, the San Marcos-In-The-Desert resort's exterior was to have been built of a textile block-and-shell system, which mimicked the zigzag flutes of the native saguaro cactus. This plaster model of the resort's exterior at Camp Ocatillo stood almost 10 feet tall. (Courtesy Frank Lloyd Wright Archives, Taliesin West, Scottsdale.)

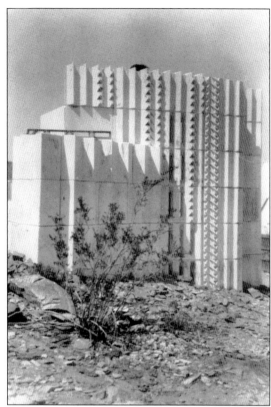

By May 1929, Wright's design of the San Marcos-In-The-Desert resort had been completed, at a projected cost of $480,000. The group broke camp in May for the summer with the intention of returning in the fall. Dr. Chandler and many of his investors suffered extensive losses in the stock market crash that October, and the resort was never built. (Courtesy Frank Lloyd Wright Archives, Taliesin West, Scottsdale.)

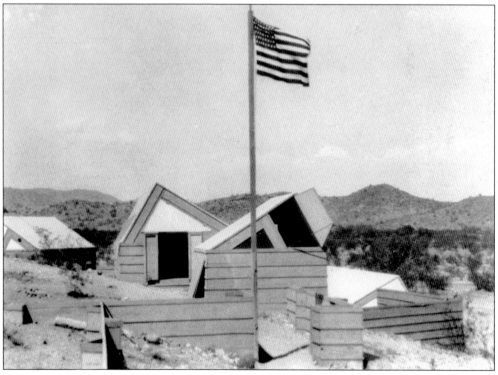

This is the setting of Camp Ocatillo in December 1982 at the time of Archaeological Consulting Services Limited's study done on behalf of Genstar and Continental Homes, developers of Mountain Park Ranch. The photograph was taken from Camp Ocatillo looking northeast over part of the site of the prospective San Marcos-In-The-Desert. Today houses just north of Desert Vista High School and Frye Road surround the knoll on which the camp stood. (Courtesy Archaeological Consulting Services Limited.)

Sunrise Easter services in the hills of the eventual Mountain Park Ranch were organized by the San Marcos Hotel for its guests beginning in the 1920s. But the San Marcos had nothing on the families in the Kyrene farming community, who had their own Easter tradition in the hills northwest of the intersection of today's Chandler Boulevard and Thirty-second Street. This photograph from Easter 1938 captures the spirit of camaraderie and friendship that characterized life in Kyrene. (Courtesy Thomas Carney.)

Four

THE AHWATUKEE RANCH

The September 29, 1921, issue of the *Chandler Arizonan* reported that a house unmatched in scope and size was being built in the foothills of South Mountain by a couple named Ames. Given its cost, size, and isolated location, the newspaper referred to it as "The Mystic House." The Ames called it their Casa de Suenos, Spanish for "house of dreams." In the 1930s, second owner Helen Brinton began referring to the house as Ahwatukee, purportedly a rough translation of the Spanish name into the Crow Indian language. The exact meaning of the word *ahwatukee* remains unclear, but in time the word came to refer to not only the house but to the land surrounding it. In its entirety, the Ahwatukee Ranch referred to the house and its grounds.

Four ranches are referenced in this book: The Ahwatukee, Lightning (chapter six), Pima (chapter seven), and Collier-Evans (chapter eight). None of them were ranches in the traditional sense of the word. The Ahwatukee and Pima Ranches were never working ranches, and any livestock was there chiefly for recreational purposes. The Lightning Ranch was solely a farming venture. The Collier-Evans Ranch did have small amounts of livestock over the years, but it too was primarily used for farming.

The son of a prominent physician, William Van Bergen Ames was born in Ohio in 1859 and educated as a dentist. As cofounder of Northwestern University's Dental School in 1891, Dr. Ames served as a professor of prosthetic dentistry. In Chicago, Dr. Ames achieved worldwide acclaim as both an inventor of the gold inlay and his "Ames Cement," which offered substantial improvement over dental cements of the time. The W. V. B. Ames Company of Fremont, Ohio, manufactured and distributed his products throughout the globe. Failing health resulted in Dr. Ames wintering in Arizona following World War I, where he decided to build a large desert home in 1921. He is pictured at left, c. 1910, and some of his company's products and worldwide destinations are seen below in a 1950s-era photograph. (Left courtesy American Dental Association; below courtesy Rutherford B. Hayes Presidential Center.)

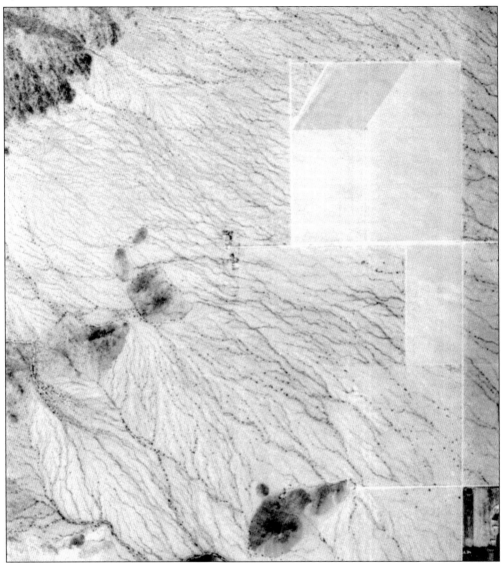

A section of land is comprised of 640 acres and is one square mile in size. The circumstances by which Dr. Ames found the site have been lost to history, but around 1920, he leased and ultimately purchased 12 sections of state land at the base of South Mountain for $4 an acre. An adobe-style house was constructed in 1921 on the easternmost portion of the land. In this 1953 photograph, the Ames property comprises most of the land to the left of the square farm field (which did not exist until around 1950), including a portion of what is now South Mountain Park. The Ames house and its outbuildings can be seen at the center of the photograph, left of the farm field, at the end of a dirt path called Warner Road. (Courtesy Wisconsin Historical Society, Whi39937.)

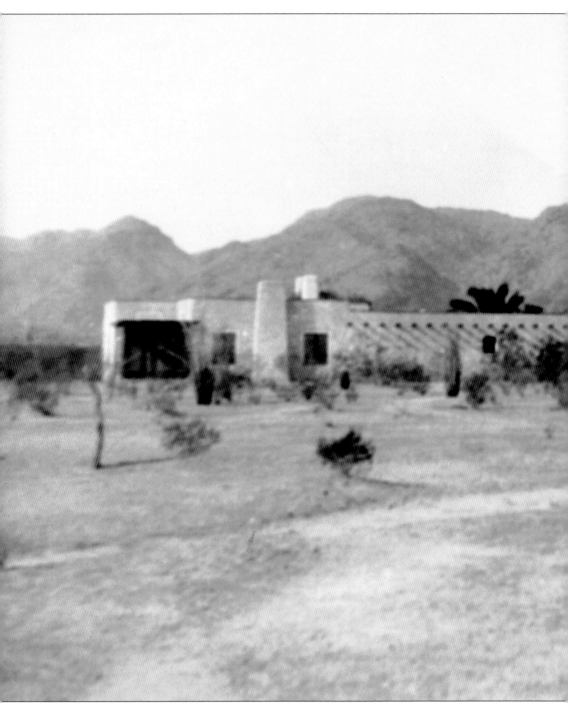

Construction of Ames's 12,000-square-foot winter residence began in February 1921. Prominent Phoenix architect Lester Mahoney and Amos P. Slawson of Chandler were, respectively, architect and general contractor. During construction, Dr. Ames and his wife lived on the property in a small adobe home in which Slawson's brother, who served as the property's caretaker, would live for 50 years. At a cost of $50,000, the house originally had 17 rooms, 7 bathrooms, 2 fireplaces,

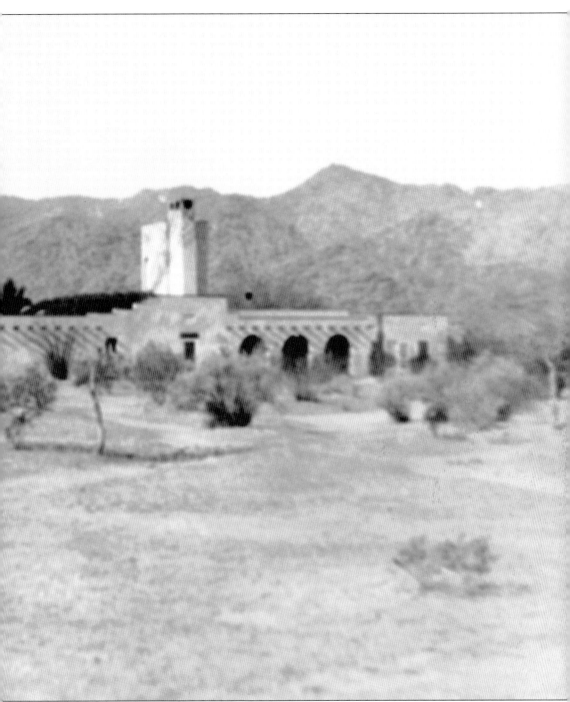

and featured an open 40- by 70-foot courtyard at its center. Dr. Ames's stay in his palatial winter home was short-lived, as he and his wife moved into the house on Thanksgiving Day 1921, and Ames died suddenly at age 62 on February 23, 1922. In this photograph looking north, c. 1936, two more fireplaces have been added as the house rises from the desert with South Mountain in the background. (Courtesy Barbara Brinton Hackett.)

About 100 yards west of the main house, a three-car garage, seen here in the early 1920s, was constructed. At the time, Warner Road was little more than a long, straight, dirt driveway, exactly two miles west of Highline Drive, which is today's Fifty-sixth Street. The floor of one of the garage bays was recessed so that one could service a car while standing underneath it, similar to some commercial garages today. (Courtesy Berma Slawson Evans family collection.)

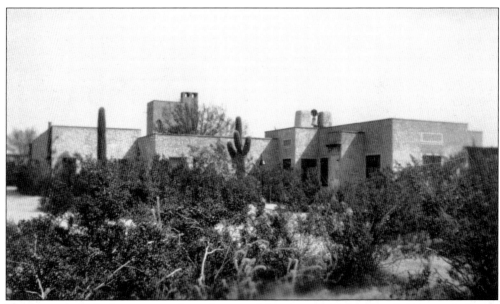

The west side of the house is seen from the rear of the garage in this undated photograph. Inside the house, a few of the elegant features included three hand-wrought-iron chandeliers in the living room that were originally made for candles but later modified for electric bulbs, a one-and-half-ton walk-in refrigerator in the kitchen, solid redwood paneling in many rooms, and white marble-covered electrical distribution panels throughout the house. (Courtesy Berma Slawson Evans family collection.)

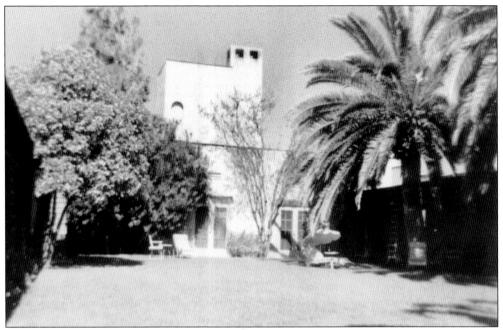

Elegant on the inside, the centerpiece of the Ames residence was a 40- by 70-foot exterior grass courtyard and patio garden around which the house was constructed. Bordered by a 12-foot-wide covered walkway, consisting of 8- by 8-inch posts, 6- by 6-inch beams, and decking, all of solid redwood, the walkway enabled one to move from any room in the house to another without being exposed to the desert sun. This 1957 courtyard photograph (above) looks east toward the house's living room, the dining room's towering chimney, and the house's 2,000-gallon water-storage tower. The early 1930s photograph (below) provides a look at a small portion of the covered walkway and lush landscaping inside the courtyard, with the stairs leading to a roof patio and small bell tower. (Above courtesy Barbara Brinton Hackett; below courtesy Berma Evans family.)

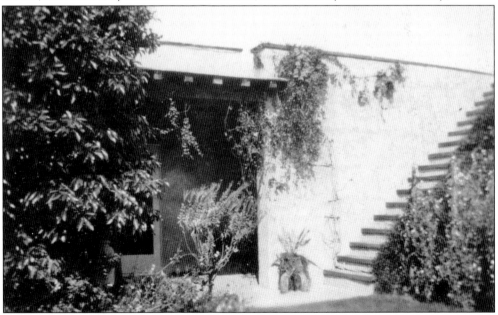

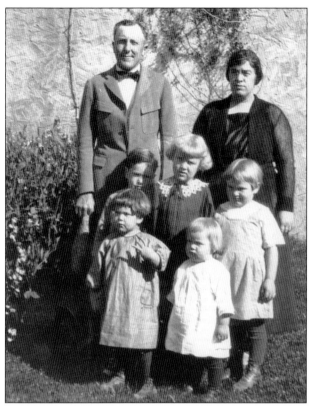

Byron Slawson, born in Indiana in 1892, homesteaded in the town of Higley before participating in the construction of the Ames house under the direction of his general contractor brother. When Dr. Ames died, Slawson assumed the position of caretaker of the property in March 1922. The Slawson family lived in the small adobe house occupied by the Ames family during construction, later modified with three bedrooms, which stood about 150 yards south of the main house. Pictured here (at left) about a year after becoming caretaker is 31-year-old Byron Slawson and his wife, Matilda (right), with, from left to right, children (front row) Wanda and Berma; (second row) Bob, Ann, and Delilah. Below is the Slawson house in the mid-1960s. (Both courtesy Berma Slawson Evans family collection.)

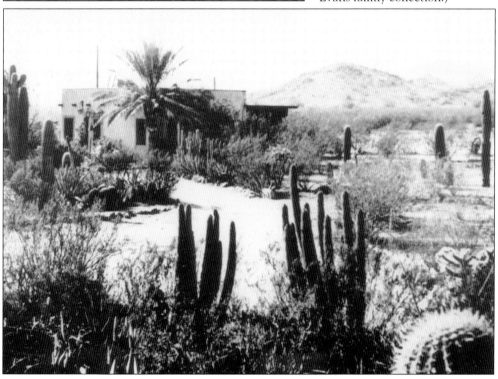

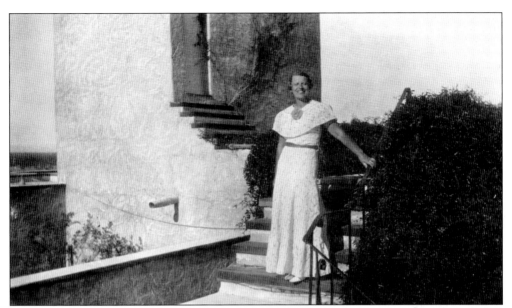

Virginia Ames was a member of a prominent Chicago family whose roots in America predate the Revolutionary War. The Slawson children fondly recalled Mrs. Ames welcoming them into her home. Following the death of her husband, she continued to spend winters in what became Ahwatukee until her death at age 78 in 1933. This undated photograph is believed to be of Mrs. Ames and was taken on a set of exterior stairs leading to the house's roof patio. (Courtesy Berma Slawson Evans family collection.)

In addition to maintaining the house and grounds, Byron Slawson's caretaker's duties extended to seeing to the needs of Mrs. Ames's houseguests. This December 1925 letter from Mrs. Ames's Libertyville, Illinois, farm advises Slawson of an impending arrival and typifies the cordial relationship between wealthy winter homeowner and her property's caretaker. (Courtesy Berma Slawson Evans family collection.)

MRS. W. V-B AMES
BRIAR RIDGE FARM
LIBERTYVILLE, ILLINOIS

Libertyville, Ill.,

Dec. 12, 1925.

My Dear Byron,

The women are leaving on Tuesday the 15th as I wrote you but they are staying all night at Ash Fork Thursday so will arrive in Phoenix on Friday evening at 8.30 (instead of nine o'clock). Please meet them taking the trailer as their baggage will probably be on train with them. I suppose you have the Ford on duty.

I hope you have received my various letters. I am sure Matilda will take care of the women as to meals , anyway at first , if she does not care to take them for all meals they can get them for themselves but until Marion arrives it would be right nice for them to be with you. After Marion arrives they will have meals in my house. (Too many for Matilda)

Marion is not yet able to say just when he will start and neither am I . If my father seems quite well during the first week of January I will leave by the first of the second week.

With good wishes,

Mrs. Ames

P.S.
Their baggage
will probably be in
Phoenix ahead of them.

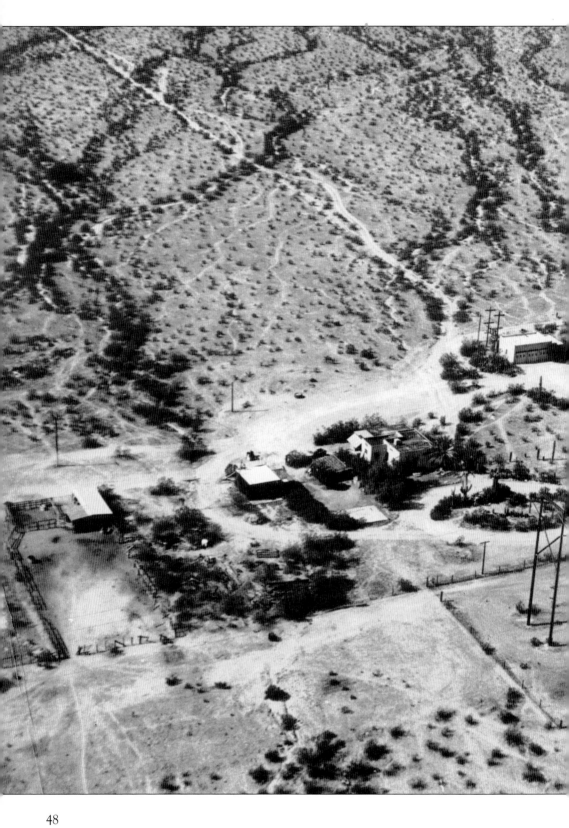

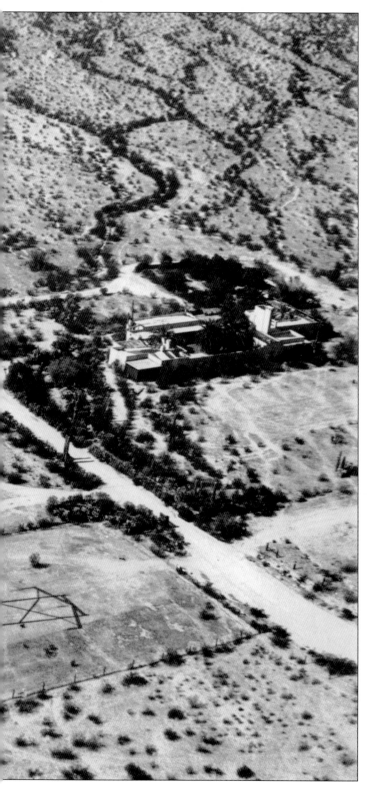

This aerial photograph provides an illustrative look at the Ahwatukee Ranch as it appeared in 1966. Viewed looking north in the direction of South Mountain are, left to right, a corral and stable, a storage structure, the Slawson house and cactus garden (the circle on its right), the garage, and the main house. Warner Road dead ends at the garage and the main house's center courtyard is marked by the tall palm trees extending over the courtyard's wall. The tall power line in the foreground was erected in the early 1950s. Today Sequoia Trail passes underneath that line and through the site of the main house, while Ahwatukee Drive was constructed where the Slawson house once stood. Both streets can be accessed via today's curving Warner-Elliot Loop. (Courtesy Berma Slawson Evans family collection.)

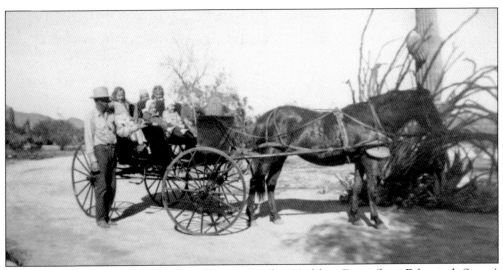

It was exactly two miles straight down Warner Road to Highline Drive (later Fifty-sixth Street) and exactly one more mile to Kyrene School, which all five Slawson children attended. For trips to school or church, the preferred mode of transportation often had four legs. Here, around 1925, the Slawsons are ready for another ride down Warner Road. (Courtesy Berma Slawson Evans family collection.)

Twelfth: I give, devise and bequeath all that I own of the section 23, range 3 east, Maricopa County, Arizona, and the north east quarter of section 13, to The Phoenix Mountain Park system.

I give, devise and bequeath the south half of section 13, including my house and the north half of section 24, including small house and other buildings, together with right to water from well on the north west quarter of section 19, also that portion of the section 18 which I own, to The St. Luke's Home, Phoenix, Arizona.

Thirteenth: I give devise and bequeath to Mary Virginia Bostick the north west quarter of the section 19, together with the use of water from well on this quarter which is to be shared with owners of the houses at this date on the sections 13 and 24.

Virginia Ames's death in 1933 came after 12 winters spent in the future Ahwatukee. Much of the Ames's original landholdings had been donated or sold before she died, but in her will, a portion of the remaining land was left to and became part of the Phoenix South Mountain park system. The Ahwatukee Ranch and the land around it, about 1,220 acres, were bequeathed to St. Luke's Hospital in Phoenix, which sold the property two years later. (Courtesy Berma Slawson Evans family collection.)

Ownership of the Ames property passed from St. Luke's Hospital to Helen Brinton in 1935. Brinton, born in 1874, was the daughter of Col. William Bradford Brinton, a United States marshal, president of the J. I. Case manufacturing company, and mayor of their hometown of Dixon, Illinois. Before fleeing the Dixon cold for the warmth of the San Marcos Hotel (page 31), the Brinton family spent several winters warming up on the East Coast. Helen is pictured above in her mid-20s, c. 1900, in the resort town of Tryon, North Carolina. Below her family gathers in the Midwest, c. 1918. Pictured, from left to right, are parents, Rhoda and William Brinton, brother Bradford, and his wife, Catherine. (Top courtesy Barbara Brinton Hackett; bottom courtesy Bradford Brinton Memorial and Museum.)

Helen Brinton was 51 years old when she bought the Ahwatukee Ranch from St. Luke's Hospital. She made it her winter home for the next 25 years until her death at age 85 in January 1960. Seen with Chicago friend Henry Ferreaux in the late 1950s, Brinton was in her early 80s when this photograph was taken at the ranch. (Courtesy Barbara Brinton Hackett.)

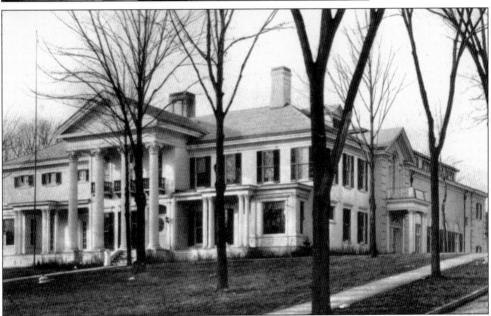

In contrast to the adobe-style Ahwatukee Ranch, the Brinton house in which Helen grew up and resided in Dixon, Illinois, logically reflected a style of architecture more adapted to the country's Midwest. In this undated photograph, the house reflects the successful affluence of William Brinton and was befitting of a man for whom the town's Brinton Avenue was named. (Courtesy Lee County Historical Society.)

In addition to bringing in her collections of paintings, etchings, and books, Brinton made several changes to the house. A billiard room was converted to a formal dining area, and the room that had been the dining area was turned into a living room and parlor. Curiously, given the area's low humidity, a screened porch was added on the southwest corner of the house, as seen here in 1956. (Courtesy Barbara Brinton Hackett.)

This January 1956 photograph of Brinton, talking with her niece Barbara Hackett, provides a closer look at the screened porch. Consistent with the features of the main courtyard's covered walkway, solid redwood posts and beams were a prominent part of the construction. Either of two bedrooms could be accessed through the porch. (Courtesy Barbara Brinton Hackett.)

On the northeast corner of the ranch, Brinton added a flagstone patio. Note the house's stucco in this late-1940s photograph; during initial construction, only one man was qualified to do the job, and he insisted on doing all of the work himself. (Courtesy Berma Slawson Evans family collection.)

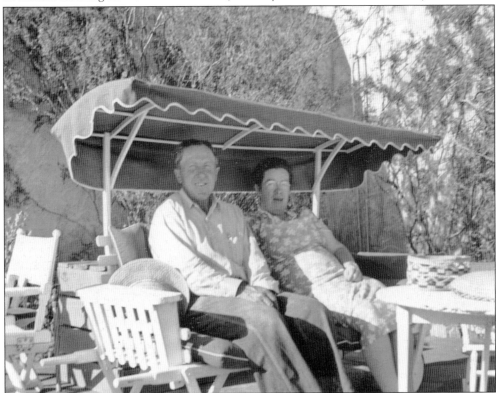

Between taking care of the ranch and raising their five children, Byron and Matilda Slawson rarely had time to rest. Here they relax on the flagstone patio during a well-deserved break in the late 1940s. (Courtesy Berma Slawson Evans family collection.)

While Brinton enjoyed a quiet and conservative lifestyle, she entertained winter guests from the Midwest at the ranch on a regular basis. This printed card served as a directional map for her visitors. The seven miles of West Chandler Road marked the distance between the San Marcos Hotel and Fifty-sixth Street, which is the north/south road labeled vertically as "2 MI. 3 MI." From Fifty-sixth Street, the ranch was two miles straight west on Warner Road, which ended at the ranch's garage. (Courtesy Berma Slawson Evans family collection.)

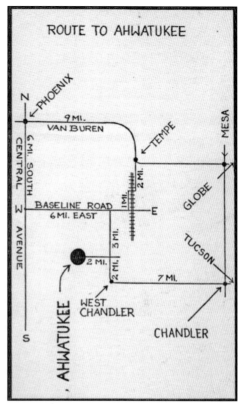

Brinton, center, and two winter visitors are seen here around the late 1950s on the northwest side of the house. Close friend and Chicago resident Marian Hosford (left) spent part of every winter at the ranch, while Mrs. Ferreaux (right) and her husband (page 52) visited less frequently. The house's library had a large, ornate fireplace at each end and is the room on the right, while the iron gate on the left opened into a rectangular courtyard. (Courtesy Barbara Brinton Hackett.)

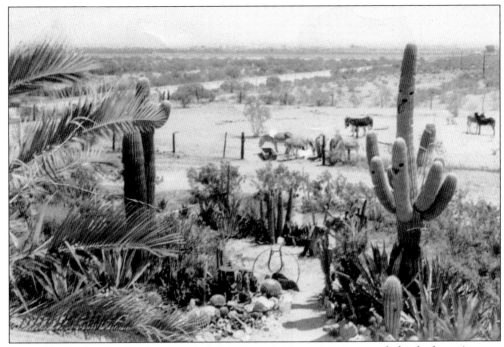

Byron Slawson's caretaker duties included rising at 4:00 a.m. in winter to light the house's water heaters, maintaining its Koehler generator until electricity replaced it in 1933, and transporting a half-dozen 300-pound blocks of ice, by wagon, to the house from Chandler every two weeks. In addition, he planted flowers, shrubs, and date palm trees for shade in the courtyards and transplanted several varieties of native cactus around the house and grounds. As Arizona's first female mail carrier, Matilda Slawson had made her rounds in the Higley area on horseback. The undated photograph above shows part of Slawson's circular cactus garden about 100 feet southeast of his house, looking east across a small fenced-in area known as "The Patch" and on past to Warner Road (top). Below the Slawsons are pictured at the southeast corner of the main house in the mid-1930s. (Both courtesy Berma Slawson Evans family collection.)

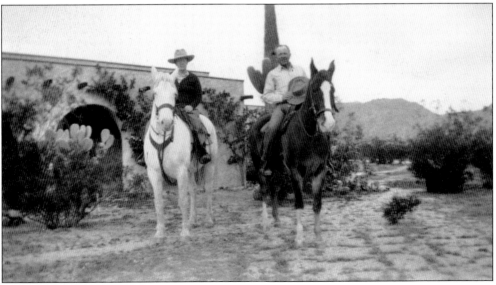

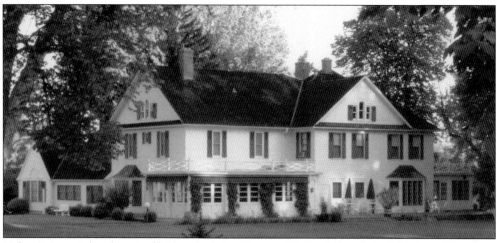

Helen Brinton's brother Bradford owned the Quarter Circle A Ranch in Big Horn, Wyoming, and used it as a vacation home. There he entertained friends, raised thoroughbred horses, and maintained his various collections. When he died in 1936, his sister inherited the Circle A. Helen Brinton used the ranch as her summer home, alternating between it and the Ahwatukee Ranch in the winter. Pictured here, the Quarter Circle lives on today as the Bradford Brinton Memorial and Museum. (Courtesy Bradford Brinton Memorial and Museum.)

Typically chauffeur driven, Brinton's car of choice was a 1931 Packard Limousine. In 1941, World War II resulted in the car being placed on jacks and stored at the ranch and its tires put on the community rubber pile for the war effort. The car remained there until March 12, 1966, when T. H. Kornegay (right) of Midland, Texas, purchased the vehicle from Byron Slawson and had it towed away. (Courtesy Berma Slawson Evans family collection.)

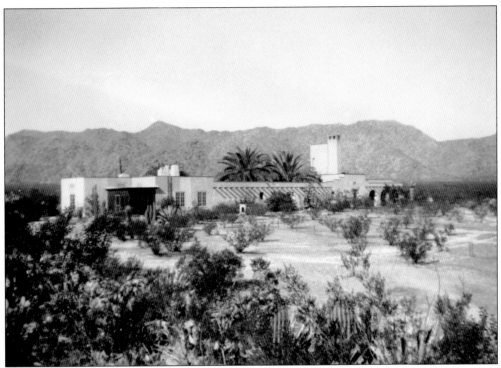

Before the freeway was built, streets paved, and master-planned communities developed, the Ahwatukee Ranch was the first, and for many years the only, non-homesteaded residence in the area that today is called Ahwatukee Foothills. As the first and grandest custom estate, it stood for 50 years in solitary isolation, its natural desert surroundings largely untouched. The above 1942 photograph shows the main house in its desert setting, while the undated photograph below preserves the view from the north side of the house looking toward South Mountain. All of the land in the photographs has been developed and today is part of Ahwatukee's Custom Estates. (Both courtesy Berma Slawson Evans family collection.)

Five

FREEWAYS AND A DAIRY

For the first half of the 20th century, the idea of a freeway running through the Kyrene farming community was unthinkable. But the Federal Highway Act of 1956 changed the landscape, bringing unprecedented mobility to the country in the form of the interstate highway system. Phoenix and Tucson were two distant and formerly hard-to-access cities before Interstate 10 was constructed as a link between Interstate 17 in Phoenix and the southern part of the state. The initial portion of Interstate 360, commonly known as the Superstition Freeway, marked the beginning of freeway access to the east valley. Many farms and dairies were displaced to make room for the freeways, but one in particular stands out.

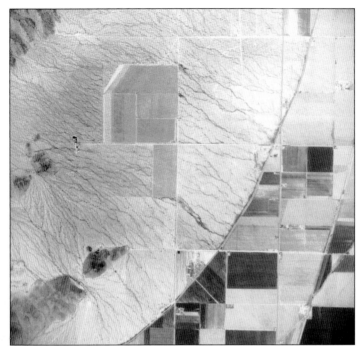

In 1964, the State of Arizona Highway Department began work on an extension of Interstate 10 in order to provide a direct north-south route between Phoenix and Tucson. This May 1961 photograph preserves the scene before the freeway was built a half mile east of the Lightning Ranch farmland (middle left), between the square-mile section lines directly to the right of the farm. (Courtesy Arizona Department of Transportation.)

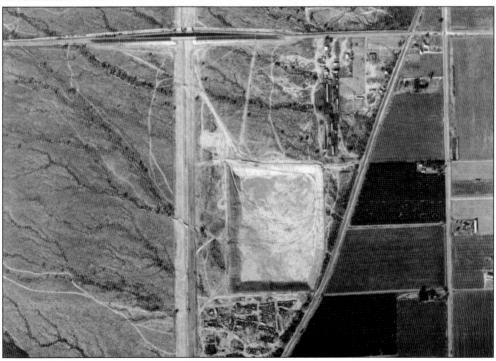

It seems like it's been there forever. That open pit on the east side of Interstate 10 between Ray and Warner Roads was excavated during freeway construction in the mid-1960s, and dirt from the pit was used to construct the Elliot and Warner Road overpasses. Seen here near Warner Road (top) in December 1965, the pit remains open today and is used primarily for drainage. (Courtesy Arizona Department of Transportation.)

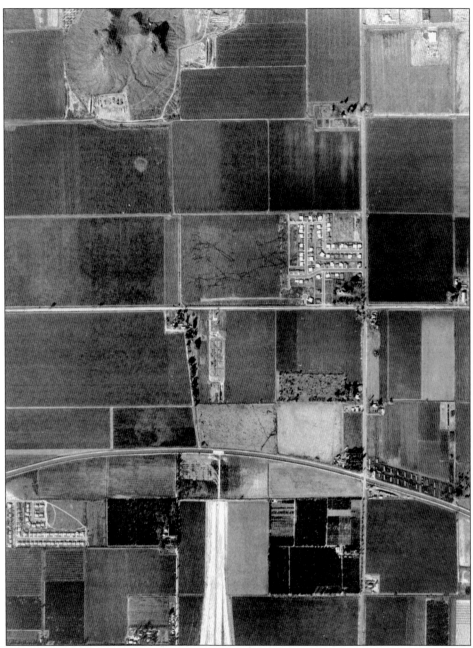

Interstate 10, also known as the Maricopa Freeway, was built in sections. The stretch between just north of Baseline Road and Chandler Boulevard remained unconnected to the rest of the freeway until late 1968, giving the future Ahwatukee Foothills area a five-mile-long concrete straightaway on which no traffic passed for a couple of years. In this December 1965 photograph, freeway excavation (the light area at the bottom) stops between Baseline Road and Southern Avenue (crossing the middle). Curving just above the freeway is the Western Canal, and along its north bank stood the Goldman Dairy (the rectangular area, lower right). Construction of the Superstition Freeway in 1967 resulted in the Goldman Dairy's relocation into the future Ahwatukee Foothills. (Courtesy Arizona Department of Transportation.)

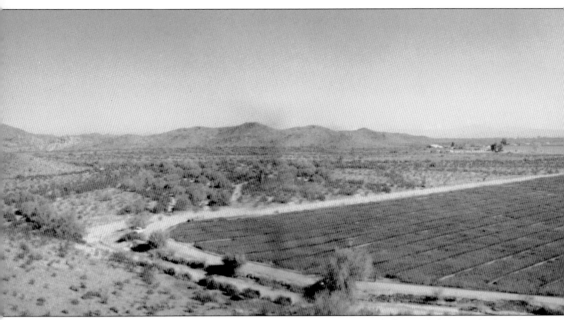

Before there was a Mountain Park Ranch, before there was a Foothills or Club West, before there was even an Ahwatukee, there was the Goldman Dairy. Faced with condemnation in 1967 by the State of Arizona Highway Department, the Goldman Dairy relocated to what would eventually become the southwestern border of Mountain Park Ranch. This picturesque panoramic view, looking east from a hill overlooking 30 acres of Goldman farmland, was taken in early 1968,

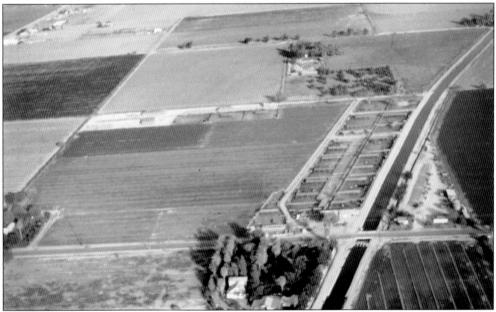

A November 1966 aerial photograph of the first Goldman Dairy shows the Goldman house (in the triangle at lower right) on the east side of Fifty-sixth Street. The dairy and farming operations are on the north side of the Western Canal (left of the triangle). Today the Superstition Freeway's on-ramp from westbound Interstate 10 crossing over the canal and Priest Drive, just north of Arizona Mills Mall, dominates the view. (Courtesy Jim Goldman.)

shortly after the dairy relocated. What would become Frye Road is at left, with Thirty-second Street in the far distance. Today this vantage point offers a bird's-eye view of Desert Vista High School, built on Thirty-second Street in the distant middle right, and its athletic fields. (Courtesy Jim Goldman.)

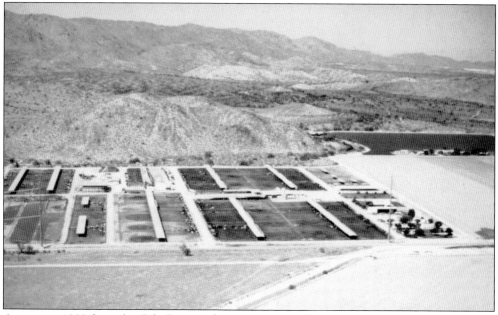

As seen in 1983 from the Gila River Indian Reservation (foreground), the relocated Goldman Dairy included 30 acres of farmland (the dark area at upper right) and 40 acres of dairy operations bordered by Pecos Road (middle). Milt Goldman purchased the land in 1967 from Bill Collier (see chapter eight), who owned the one square mile to the east that became Lakewood and 40 acres adjacent to both Goldman parcels (middle right). (Courtesy Jim Goldman.)

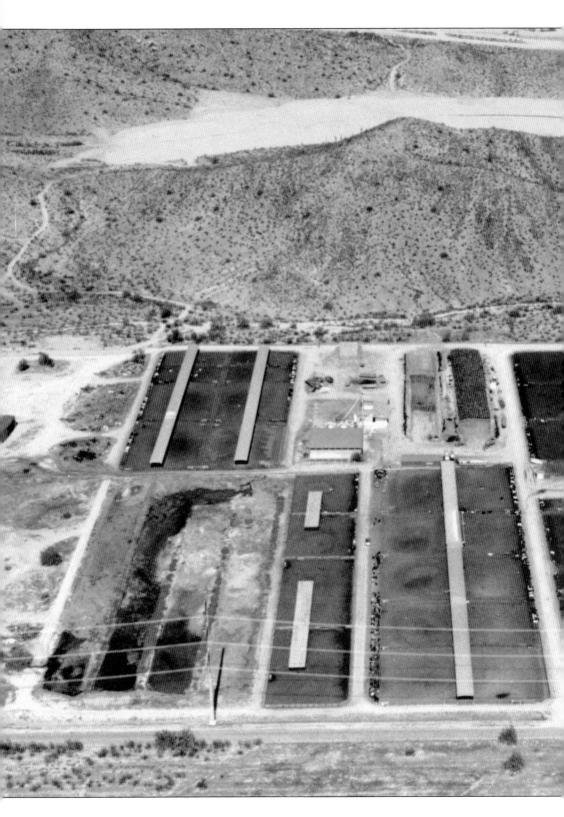

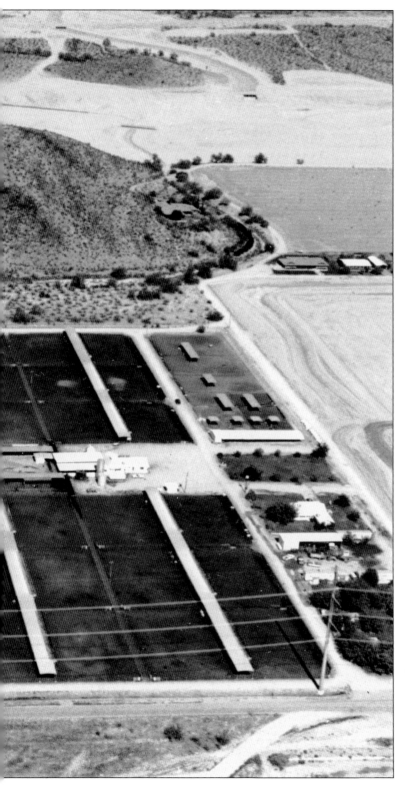

The open land on which the dairy once stood retains little evidence of its agricultural past. Clockwise from upper right, the dirt road bordering the Goldman farmland is now Frye Road, with Vista Canyon Park on the north and a Latter-Day Saints church on the south side of it. Milt Goldman's sons' houses (extreme right of photograph) are on what became Glenhaven Drive, on the western edge of Lakewood. Liberty Lane now horizontally bisects the lower third of the dairy land, with Kyrene Akimel A-al Middle School on the right half of the acreage and Kyrene de la Estrella Elementary school on part of the left half. Out of the photograph, on the extreme right, is the current site of Desert Vista High School. Two constants remain from this 1983 photograph: Pecos Road (bottom of photograph) and Milt Goldman's house on the hill (extreme right of the hill). In 1986, the Goldman Dairy relocated once again, to Coolidge, when development started closing in. (Courtesy Jim Goldman.)

Moving can be unpleasant, unless the move provides an opportunity to build a dream house in a spectacular location. In 1968, Goldman and his wife, Margaret, selected a site overlooking their dairy, which offered sweeping vistas of Tempe and Chandler to the east, the Gila River Indian Reservation to the south, and the Estrella and South Mountains to the west and north, respectively. The Goldmans stayed on into the early 1990s, and their house remains as a tribute to the area's serene agricultural past. (Courtesy Jim Goldman.)

Moving to the future Mountain Park Ranch and Lakewood borders before anyone else had its distinct advantages. Milt Goldman wore the smile of a man who had it all in December 1970, as he mortared the backyard wall of his new house on the hill. (Courtesy Jim Goldman.)

Six

AHWATUKEE

It would be difficult to overstate the impact that the development of Ahwatukee had on the Valley of the Sun, or the risk the developer took in seeking to create the first master-planned community south of South Mountain. Wells had always been the source of water at the Ahwatukee and Lightning Ranches but were never an economical method for water procurement. Lack of water access was the main reason local farmers regarded the area as having little value. Randall Presley took a huge gamble in seeking to develop a community in an area where essential water and sewer service were by no means guaranteed. But Presley's vision prevailed, and the success of Ahwatukee paved the way for the other master-planned communities that followed.

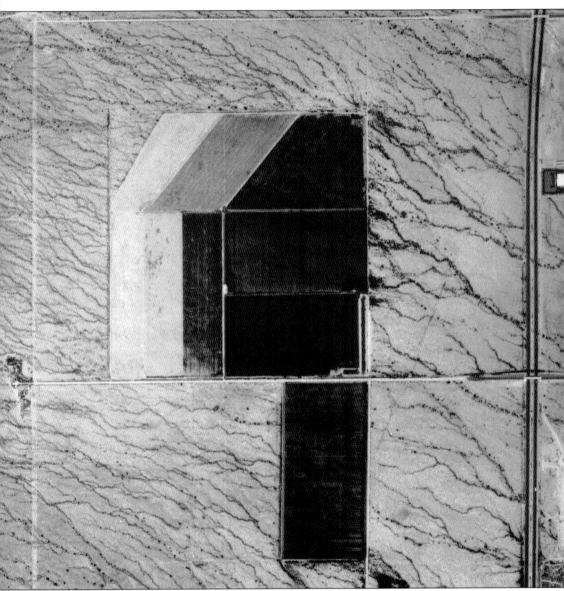

The Ahwatukee Ranch, left, was comprised of about 1,220 acres when Helen Brinton owned it, with the main house a few hundred yards from the eastern property line, seen here as the straight line in front of the ranch. This marks the Forty-first Street alignment, on which Salt River Project's large power poles were placed in the early 1950s. East of that, about 800 acres of the future Ahwatukee had been owned since the early 1930s by the Lightning Delivery Company of Phoenix. Lightning leased about 400 acres of its land for farming, with wells dug for irrigation. By the time of this 1971 photograph, Interstate 10 and its overpasses had been constructed, with Warner Road (running across the lower middle) leading to the ranch and Elliot Road (one mile north of it, at the top) providing access to the farmland. Both were dirt roads at the time. Across the freeway (extreme right) stood a solitary U-Haul building. The distance from the freeway to the ranch was one and a half miles, while a half mile of barren desert separated the freeway and farmland. Running along the eastern edge of the farm, from top to bottom, is the alignment of the future Forty-eighth Street. (Courtesy Landiscor, Inc.)

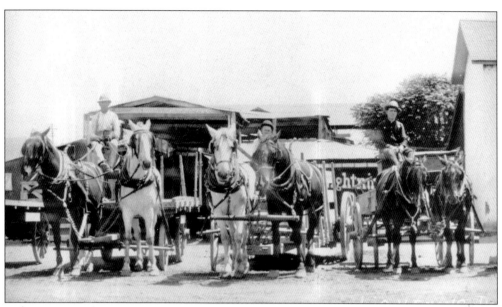

Lightning Transfer and Storage Company began in Phoenix with a single horse and wagon in 1890. From humble beginnings using mules and wagons to haul machinery for the construction of Roosevelt Dam over the Apache Trail, the company became one of Phoenix's largest movers and warehousers. Led by the Coffin family, it had grown to over 350,000 square feet of storage space by the time this 1970 photograph, below, was taken. Part of the company's early fleet is pictured above in 1912, when "lightning" was more of a relative term. The circumstances of the company's acquisition of its 800 acres in the future Ahwatukee remains unknown. (Courtesy Graebel/Lightning Movers, Inc.)

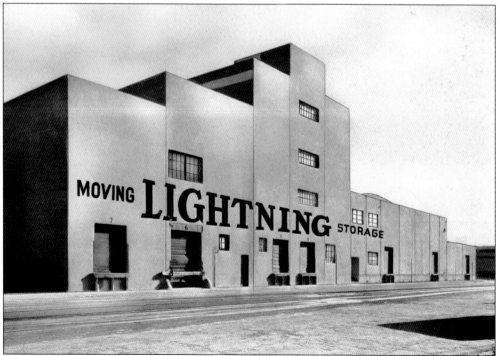

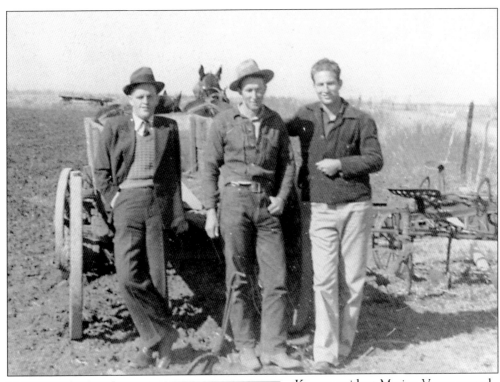

Kyrene resident Marion Vance owned a farm about a mile east of what was known as the Lightning Ranch and farmed thousands of acres in the towns of Tempe and Maricopa. Vance leased the Lightning farmland beginning in February 1960 and for the next decade was the sole farmer of the land. Pictured here in the early 1940s are Vance (center), unidentified, and best friend and country doctor Ben Howland (left). Whoever farmed the land prior to 1960 is not known. (Courtesy Vance family.)

Growing primarily cotton, Vance cleared 80 acres immediately south of Warner Road (the rectangular section on page 68) and added it to the farm. Under his sharecropping arrangement with Lightning, he kept half of what he made and Lightning got the other half. Here the father of 10 is seen in his early 80s during the mid-1990s. (Courtesy Vance family.)

If Herbert Gates built Ahwatukee Foothills' first swimming pond, then Marion Vance very likely built its first swimming pool. Vance dug out and cemented a six-foot-deep, 100- by 30-foot irrigation holding pen in the path of a well, which quickly filled whenever water was pumped. The water was cold, but this primitive swimming pool was a popular gathering place for Kyrene residents. The pool appears as the light rectangle at the center. (Courtesy Landiscor, Inc.)

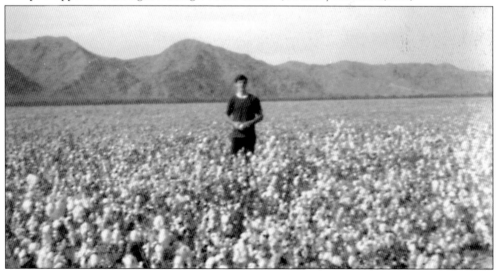

There was no waiting on the first tee—or on the second, or in the restaurant, for that matter. Marion Vance's 12-year-old son Mike had the future Ahwatukee Country Club and its golf course all to himself in 1968, as he stood amidst acres of cotton on the Lightning Ranch prior to development in the early 1970s. This view looking north toward South Mountain gives a sense of Ahwatukee's peaceful isolation in the 1960s. (Courtesy Vance family.)

Seen here in his mid-20s, Randall Presley first visited Arizona for pilot training at Thunderbird Air Field in the west valley during World War II. He began pursuing his real estate broker's license the day he got out of the United States Army Air Corps in 1946, subdividing three acres of land in Bakersfield, California, in his first venture. By 1969, The Presley Companies were building master-planned communities in several states on the East and West Coasts, and Presley once again had his sights set on Arizona. (Courtesy Pamela Presley Giamarra.)

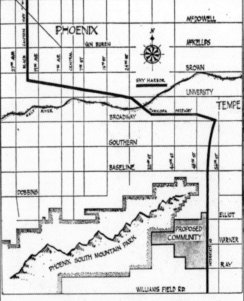

To be developed

Map locates the area of community proposed for the southeastern foot-hills of the Salt River Mountains of South Mountain Park. The community is being planned to accomodate 23,000 residents in patio and single-family homes, apartments and townhouses. Story on Page B-1.

A headline in the July 25, 1971, *Arizona Republic* announced, "Foothill Community of 23,000 Planned," and it referred to Presley Development Company's purchase of 2,080 acres of land on the site of the former Ahwatukee and Lightning Ranches. A master-planned community on the south side of South Mountain, perceived to be far from established cities and with no readily available source of water, seemed foolhardy to many at the time. (Courtesy *The Arizona Republic*; Gus Walker, artist, used with permission.)

A. Wayne Smith, whose future work would include award-winning Mountain Park Ranch and The Foothills as well as the Chandler community of Ocotillo, designed Ahwatukee's original master plan. Smith's influence can be seen today in Ahwatukee's curving arterial streets and integration of open spaces with residential construction. As a gentleman farmer, Smith is owner and proprietor of The Farm at South Mountain.

On September 16, 1971, the Maricopa County Board of Supervisors considered the Presley Development Company of Arizona's plan to develop an initial 410 acres of Ahwatukee. Scottsdale resident Carolina Butler attended the hearing and was the sole anti-development voice in the room. Expressing many concerns still raised today, Butler's pleas for water conservation, preservation of the desert, and against urban sprawl went unheeded. Presley's development plans were approved two months later. (Photograph by Melissa Jones; courtesy Carolina Butler.)

In early 1972, Presley commenced work on its first construction project in Ahwatukee, the country club golf course. Using a couple of irrigation wells already present for its lakes, the course was built right on top of the land that Marion Vance had farmed. The golf course construction marked the start of the slow transformation of the Kyrene farming community from one of agriculture to one of planned residential development. (Courtesy Robert Peshall.)

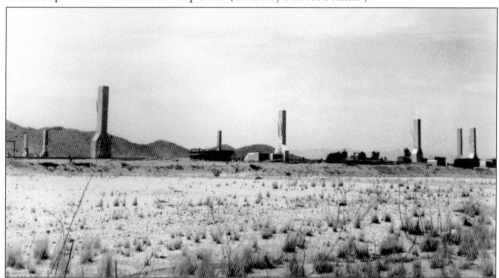

While work on the golf course progressed, Presley constructed 17 model homes easily visible to drivers on Interstate 10. Given Ahwatukee's remoteness at the time, many a passing motorist did a double take upon seeing clusters of fireplace chimneys rising up from the otherwise barren desert. After initially considering the name Foothill Park for its new development, Presley adopted the Ahwatukee name, which to many skeptics only added to the strangeness of the project. (Courtesy *Ahwatukee Foothills News.*)

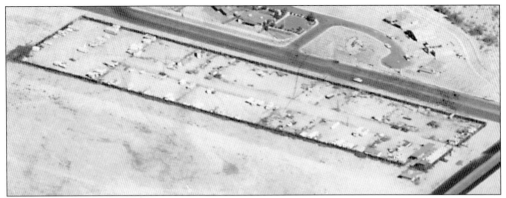

Presley Development employed its own sales team but supervised construction done by outside contractors. A secure place to keep the contractors' equipment was needed, so in spring 1973, Fort Ahwatukee was constructed on the southwest corner of Elliot Road and Forty-eighth Street on the western edge of the project. Seen here in 1977, the walled fortress consisted of hundreds of telephone poles at staggered heights standing side by side. Today the corner is home to the Ahwatukee Mercado Plaza. (Courtesy Chad Chadderton.)

The 17 model homes were built on what would eventually become Mesquitewood Drive, just off of Fifty-first Street, and are private residences today. Since the word "retirement" appeared on three of the four signs at the model complex, entertainer Tennessee Ernie Ford seemed a logical choice to be the company spokesman. He appeared in numerous radio spots and print ads for Presley throughout much of 1973. (Courtesy Robert Peshall.)

Mack and Elly Roach hold a notable place in Ahwatukee Foothills history. In September 1973, they were the first homeowners to move into Presley's fledgling development, at 5010 Magic Stone Drive, where they would reside for almost the next 30 years. In a community whose population approximates 87,000 as of this writing, the Roaches lived in Ahwatukee on the day or so when the population numbered only two. (Courtesy *Ahwatukee Foothills News.*)

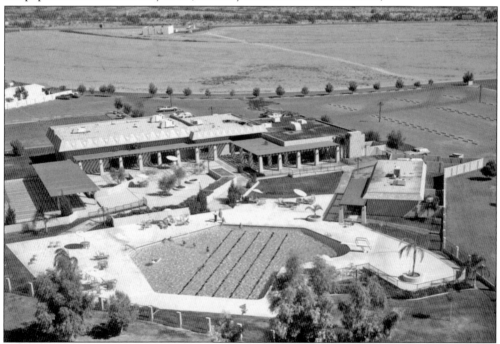

In February 1974, the Ahwatukee Retirement Recreation Center opened on Cheyene Drive and quickly became a social and activity hub for many residents. This August 1977 view looks northwest to the recreation center, with the small white building in the distance a Circle K on Elliot Road, which for several years was Ahwatukee's only food store. (Courtesy Landiscor, Inc.)

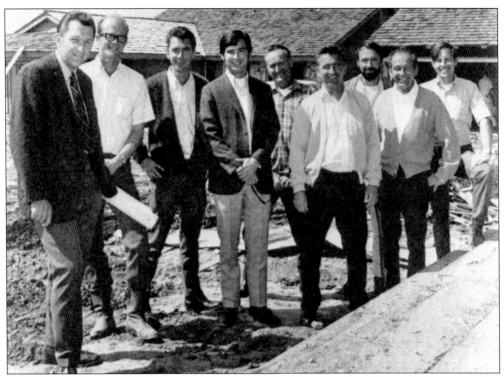

The Presley Companies had been building houses for 25 years when Ahwatukee's master plan was approved. Pictured here on an Irvine, California, project in 1969 is Presley's California team consisting (from left to right) of Dan Verska, John Radditz, Ron Bannister, Eddie Mysliwy, Fred Beck, Jerry Happeny, Jerry Dunlap, Jim Happeny, and trainee Bruce Gillam. Verska presided over the considerable challenges of Ahwatukee's initial development, while Gillam succeeded him as president and oversaw Ahwatukee's growth through 1987. (Courtesy Bruce Gillam.)

To help foster a sense of community, Presley Development hosted a Fourth of July golf tournament and fireworks show, attended by about 200 people, at Ahwatukee's new country club in 1974. The community's first Easter Parade, also initially sponsored by the developer, followed in 1977. Both events became annual traditions. The fireworks display was moved to nearby Rawhide in 2006, the year the parade celebrated its 30th anniversary. A scene from the first Easter Parade is pictured here. (Courtesy Sheila Pruitt.)

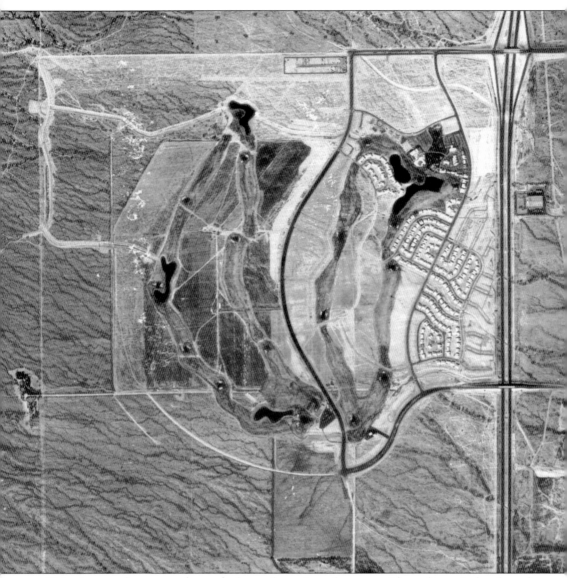

This photograph captures the gradual transformation of an area with a solitary, isolated ranch, several hundred acres of farmland, and water supplied by a few wells, to the beginnings of the residential community and its modern infrastructure of today. In this 1973 photograph, the Ahwatukee Ranch remains undisturbed, but Warner Road is no longer the straight road that it had been. The golf course covers the Lightning Ranch farmland, although the outlines of the farm fields are still clearly visible as are some property section lines (the straight lines at top and left). Less than 200 houses dot the landscape in the newly constructed development, with pavement on Warner and Elliot Roads ending at Forty-eighth Street and the loop configuration barely an outline in the dirt. The rectangular Fort Ahwatukee stands guard at the top of the photograph, with streetlights, street signs, and fire hydrants still a year away. (Courtesy Landiscor, Inc.)

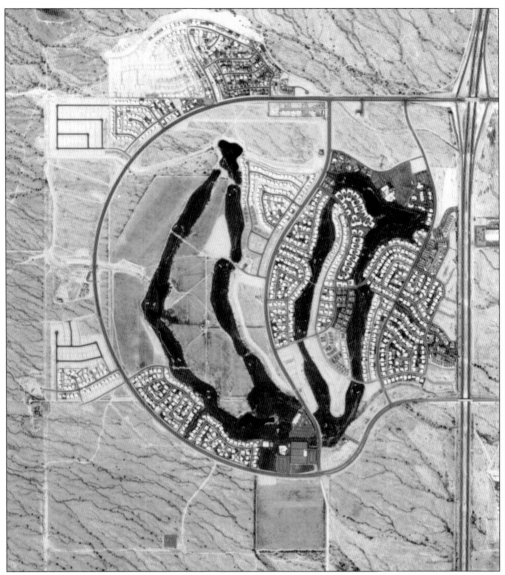

Although the farmland's outline could still be seen in 1977, the completed Warner-Elliot Loop meant that houses weren't far behind. Just as 1973 marked the beginning of an evolution from one way of life to another, 1977 marked the presence of a few modern amenities that gave Ahwatukee a growing sense of independence as its own community. The development's first store of any kind, a Circle K on Elliot Road (right of Fort Ahwatukee, at the top) opened in 1976. Fourteen tennis courts on the northwest corner of Warner Road and Forty-eighth Street (inside the loop in the lower portion) had been constructed adjacent the Ahwatukee Country Club and in use since 1975. The small community's first house of worship, Mountain View Lutheran Church (the tiny square south of The Fort), and its first school, Kyrene de Las Lomas Elementary School (outside the loop, above the small paved roads at left), both followed a year later. Equestrian Trail, The Lakes Golf Course, and an Alpha Beta shopping center were all still in the future. (Courtesy Landiscor, Inc.)

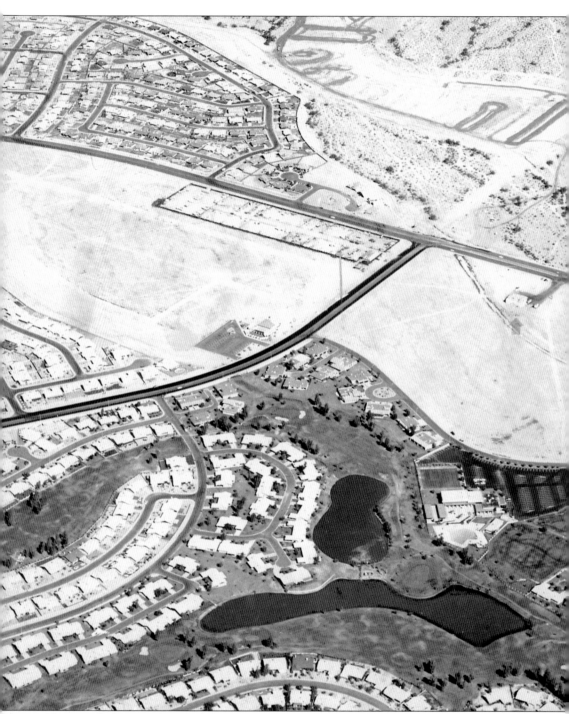

This aerial photograph provides a closer look at Elliot Road in 1977. Viewed northwest over Interstate 10 (right), Fifty-first Street was and remains the first left turn for westbound drivers exiting the freeway. Presley Development's sales office and model houses are pictured here among the first group of buildings on Fifty-first Street, with the Retirement Recreation Center on Cheyene Drive north of the golf course. Fort Ahwatukee and Mountain View Lutheran Church (top and

bottom, respectively) stand west of the intersection of Cheyene Drive and Forty-eighth Street. People in Ahwatukee would have to rely on the Circle K store (right of The Fort on Elliot Road) for another three years before an Alpha Beta supermarket was built on the southwest corner of Fifty-first Street and Elliot Road. It opened in January 1980 and today is home to a Gold's Gym. (Courtesy Chad Chadderton.)

In July 1971, Presley Development Company approached the city of Tempe with the proposal that the city assist it in getting essential water and sewer service in exchange for future annexation of Ahwatukee. Tempe declined, as did the city of Chandler when subsequently approached. In early 1972, Phoenix mayor John Driggs agreed to provide water and sewer hookups in exchange for Presley's cooperation in a future annexation. Without any source of revenue from as-yet-undeveloped Ahwatukee, annexation at that time made little sense for the city. With development in progress, Phoenix mayor Margaret Hance strip-annexed a 20-foot-wide parcel of land adjacent Interstate 10 running the length of Ahwatukee in 1978, effectively preventing annexation by any other municipality. Grassroots efforts kept the matter in dispute until 1987, when Ahwatukee officially became a part of the city of Phoenix. (Both courtesy City of Phoenix.)

A journalism major from Nebraska, Clay Schad founded the *Ahwatukee News* as a monthly four-page circular with a press run of 2,000 in July 1978. Schad ran the paper for the next 20 years, until its purchase by the Tribune Company in 1998. Today, as the *Ahwatukee Foothills News*, the biweekly newspaper has a press run of 28,000. (Courtesy *Ahwatukee Foothills News*.)

Circle K opened its doors in the spring of 1976 as the first retail establishment in burgeoning Ahwatukee. Three and a half years later, Mobil Corporation opened the second, a gas station on the southeast corner of Fifty-first Street and Elliot Road. At the time, gas was 65¢ a gallon. Managing the station was 25-year-old former Scottsdale police officer Mark Salem, who was all smiles as he awaited his first customer on opening day, October 2, 1979. (Courtesy Salem Boys.)

Randall Presley knew that creating interest in and attracting people to the first master-planned community on the south side of South Mountain would require something creative, dramatic, and very different. With the exception of a few Arizona State University students in the early 1970s, no one had lived in the Ahwatukee ranch house since 1960. Converting the house into some type of attraction was considered but deemed impractical. Presley conceived the idea of a futuristic house that would serve not only as a marketing tool for his relatively new project, but one that would also have a positive impact on the community. This early vision would ultimately result in Ahwatukee's "House of the Future." The deteriorating ranch house, seen here looking east in the mid-1960s, was bulldozed in 1975. (Above courtesy Presley family; below courtesy Berman Slawson Evans family collection.)

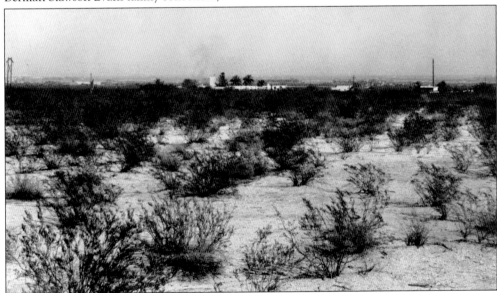

Presley Development of Arizona approached Frank Lloyd Wright's widow, Olgivanna, in 1978, with its concept of a futuristic house. Charles Schiffner, a 29-year-old staff architect at Taliensin West's Frank Lloyd Wright Foundation, was selected to design the House of the Future. Schiffner was guided by Randall Presley's three core marketing concepts: The house must be different, have a unique visual impact, and serve as a demonstration home that could accommodate large numbers of people touring the structure. (Photograph by Peter Schwepker; courtesy *The Arizona Republic*, published February 24, 1980.)

Using a computer as an appliance to control and regulate most household functions was a revolutionary concept for its time and one employed by Charles Schiffner in the House of the Future. With the era of the personal computer still a couple of years away and the movie *Star Wars* still fresh in people's minds, the House of the Future seemed very futuristic indeed when completed in late 1979. (Courtesy Charles Schiffner.)

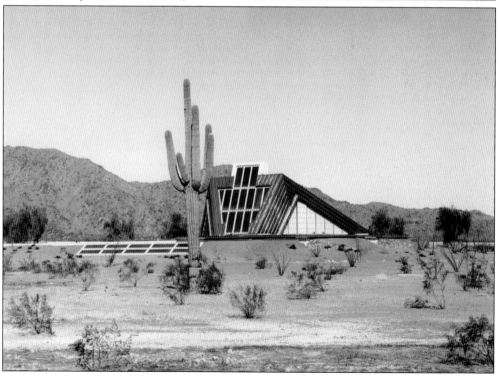

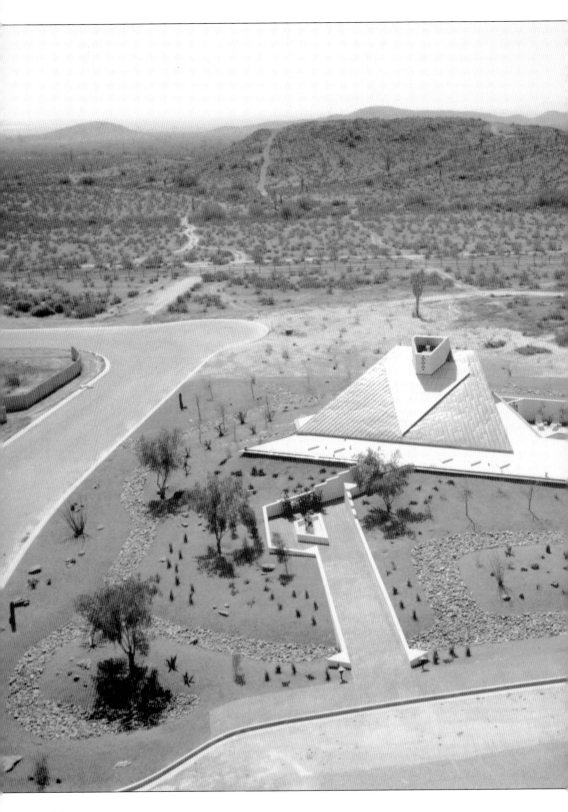

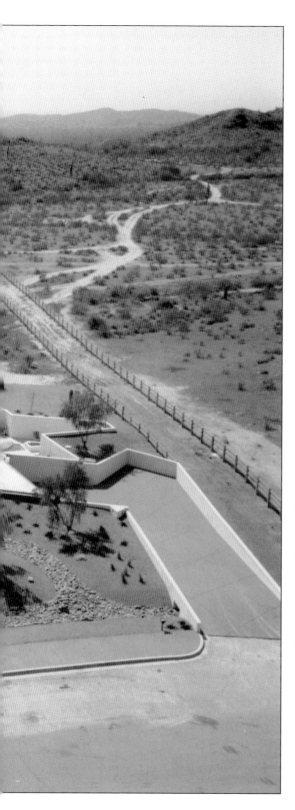

On just over an acre of land west of the Ahwatukee core, the House of the Future was constructed three feet below ground level. This 1980 aerial photograph shows the house on Equestrian Trail (foreground) shortly after completion. The land in this southwest view of Ahwatukee's Equestrian Estates section was undisturbed at the time with the exception of the horse trail constructed in anticipation of future development. The House of the Future was intended to counter the lingering perception that Ahwatukee was too isolated as well as to stimulate more awareness of the master-planned community's existence. If it wasn't already, the House of the Future definitively put Ahwatukee on the map. Worldwide publicity was generated, with coverage extending to 33 countries and the house featured on national television shows such as PM *Magazine* and *That's Incredible*. (Courtesy Charles Schiffner.)

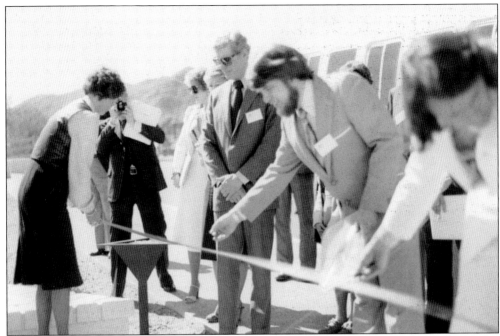

The House of the Future's grand opening was on March 28, 1980. Among the dignitaries scheduled to attend was Pres. Jimmy Carter, who was unable to do so when the Iranian hostage crisis intervened. Randall Presley, above in sunglasses, was on hand for the ceremonial ribbon cutting and to help celebrate the fruition of his visionary idea. (Courtesy *Ahwatukee Foothills News*.)

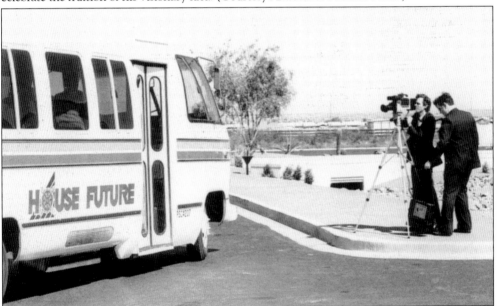

Guided tours of the house were given every half hour. Presley Development of Arizona ran a fleet of tour buses from a storefront on Elliot Road that was close to the freeway in order to accommodate the large crowds. Between the time public viewing of the house began in early 1980 and the last tour was given on March 31, 1984, an estimated 250,000 people toured the House of the Future. (Courtesy *Ahwatukee Foothills News*.)

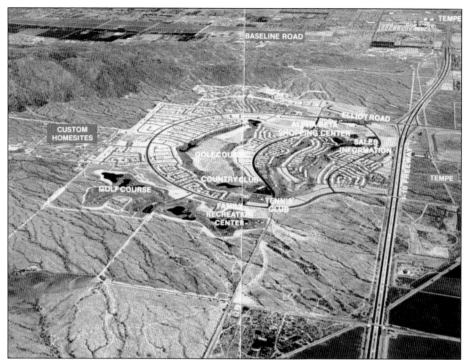

A second golf course and 640 acres of a custom homesite section had pushed development west to South Mountain preserve when this promotional brochure photograph was taken in 1982. Ray Road, bottom, ended before reaching the Pima Ranch buildings (see chapter seven) at the extreme lower left of the photograph. Development of Mountain Park Ranch was soon to begin. (Courtesy Landiscor, Inc.)

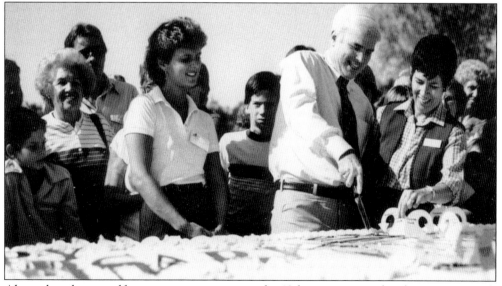

Ahwatukee threw itself a party to commemorate the 10th anniversary of its first move in, with Congressional representative John McCain on hand to help the community celebrate on November 5, 1983. Featured on the giant cake, only slightly smaller than actual size, were iced reproductions of the Warner-Elliot Loop and country club golf course. (Courtesy *Ahwatukee Foothill News*.)

Interstate 10 on the east and South Mountain on the west give Ahwatukee its clearly defined geographic borders. Presley Development Company's location of retirement sections in the center of the Warner-Elliot Loop, mixed housing outside of that, and retail close to the freeway typically keeps traffic moving and heavy volume off of residential streets. By the time this photograph was taken in 1989, the newly created master-planned communities of Mountain Park Ranch, Lakewood, and The Foothills had joined Ahwatukee on the south and southwest. With no clearly defined borders such as a freeway or mountain to separate each community, the entire 37.5-square-mile area was officially christened the Village of Ahwatukee Foothills in 1991. (Courtesy Landiscor, Inc.)

Seven

MOUNTAIN PARK RANCH

Two historically significant events at both the eastern and southwestern borders of the future Mountain Park Ranch occurred in 1929. William Belden implemented plans to build an extravagant winter home, while Dr. Alexander Chandler commissioned the design of a lavish resort on 600 acres (chapter three). History was altered when neither Belden's house nor Chandler's resort were built. In the two miles between these proposed structures, Pima Ranch remained largely unspoiled desert for much of the 20th century. When development did occur, little of the skepticism that had plagued Ahwatukee existed, and Phoenix eagerly welcomed its largest master-planned community at the time into the city.

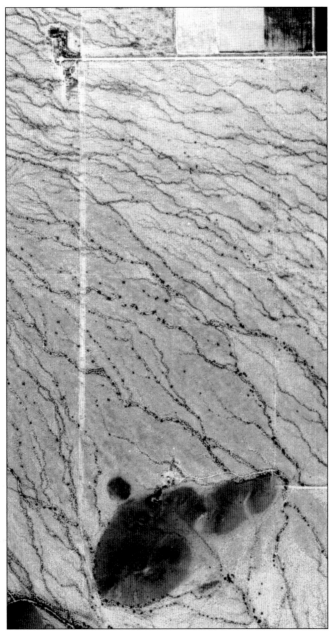

In 1929, the same year in which Camp Ocatillo was established to begin design of the proposed San Marcos-In-The-Desert resort (chapter three), New Yorker William Belden purchased 300 acres of raw desert about two miles east of the proposed resort site. Belden, seeking a dry climate due to his severe asthma, paid $115 an acre for the land. He intended to build a winter home of a size and scope comparable to that of the Ames residence on a hill overlooking the property (the largest of the three hills seen at bottom center). At the time, Ray Road was called Pima Road and ended on the right side of the hill (lower right), just west of today's Forty-eighth Street. Owing to its location, the property was called Pima Ranch. As this 1971 photograph shows, exactly one mile of undisturbed desert separated the Ahwatukee Ranch house on Warner Road (top) from Belden's ranch at the end of Pima Road. (Courtesy Landiscor, Inc.)

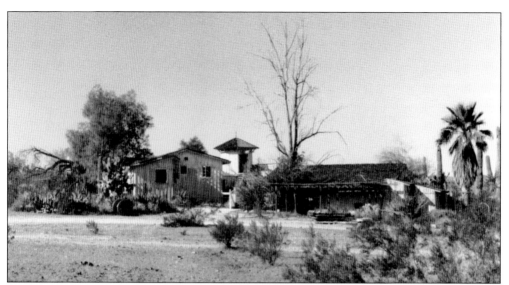

Belden built a caretaker's house, a five-stall stable, and a three-car garage that was tucked into a saddle at the base of the hill on which the main house was to be constructed. This photograph, looking southwest, shows the remains of the three structures in March 1984. The hill for the main house is on the left, out of the photograph. Today Mountain Park Apartments on Ray Road sit in the foreground of the photograph, just west of Ranch Circle South. (Courtesy Evelyn Dye.)

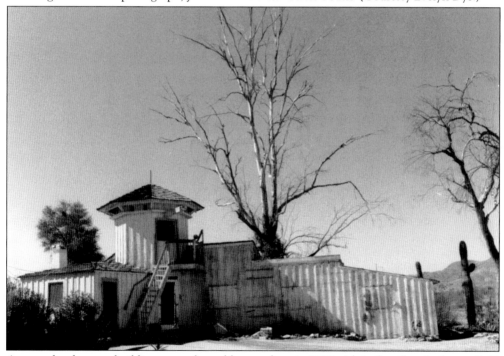

Among the three outbuildings were the stable, seen here in 1982 with its first-floor bedroom (left) and a second-floor pigeon coop, which was originally designed to house a water-storage tank. When William Belden died suddenly in the summer of 1930, his wife abandoned plans to build the main house and instead remarried and wintered periodically at the ranch in the remodeled caretaker's house. (Courtesy Kathleen Raife.)

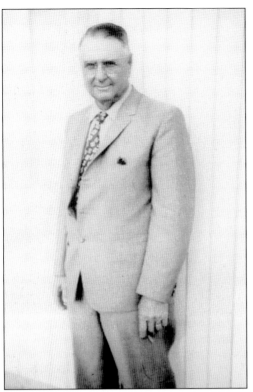

The cost of the unbuilt main house was projected at $50,000, a tidy sum in 1929. Until his death a year after buying the property, Belden relied on local resident Mac Owens to oversee initial construction at Pima Ranch. In a field near Warner and Rural Roads, Owens manufactured close to 50,000 adobe bricks that were to have been used for the main house. Owens is seen here at age 65 in 1965. (Courtesy Jack Owens.)

In the early 1930s, William Belden's wife remarried a man named Boeckl, and they and her son, William Jr., wintered periodically at Pima Ranch over the next few decades. The Boeckls lived in this house, one of the three structures built in 1929, which was intended to be a caretaker's residence. Pictured here in 1982, the small, two-bedroom house had a wooden front patio (right of photograph and beyond), screened porch in the rear, and a fireplace in the larger bedroom. (Courtesy Kathleen Raife.)

Pima Ranch never housed more than only a few pet horses and other barnyard animals, although chickens numbered about 5,000 at one point. As it grew to encompass over 2,000 acres, the land that would become Mountain Park Ranch remained undisturbed, pristine desert for much of the 20th century. William Belden, and later the Boeckls, loved its magnificent vistas of South Mountain and wanted to preserve the land in its original condition. In the picturesque scene above from December 1952, cows from the nearby Gates Dairy graze serenely in their peaceful surroundings. Sheep wintering on Pima Ranch land was a common sight through the 1980s, as this undated photograph below reflects. (Above courtesy Gates family; below courtesy *Ahwatukee Foothills News*.)

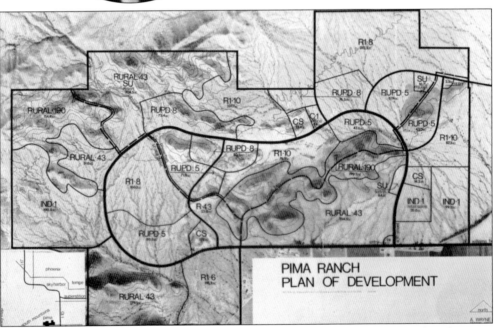

LeRoy Smith, a Delta, Utah, native pictured here in the early 1980s, acquired vast landholdings in the future Ahwatukee-Foothills area. In the mid-1970s, he sold Presley Development Company the 640 acres that became Ahwatukee's Equestrian Estates section. By the late 1970s, Smith owned the 2,670 acres that would become Mountain Park Ranch, including most of the Pima Ranch land. (Courtesy A. Wayne Smith.)

PIMA RANCH
PLAN OF DEVELOPMENT

To help market his property, Smith enlisted A. Wayne Smith (no relation; see page 73) to draw up a preliminary development plan for the 2,670 acres. This 1977 version had Ray Road (the topmost curve at upper right) extending only a half mile past the Pima Ranch buildings, with Smith's characteristic inner loop serving as the main arterial street. A grand entrance to the community was envisioned where Fortieth Street met Chandler Boulevard (tiny semicircle, bottom right). Once the property was sold, Vernon Swaback designed the development's master plan. (Courtesy Don Cox.)

Charles Keating's Continental Homes Corporation purchased the Pima Ranch property in the early 1980s. Together with Canadian firm Genstar, Inc., Continental planned the initial development of Mountain Park Ranch. That included the extension of Ray Road farther west, past the spot at which it had ended for decades. Ray Road's dirt outline (middle of the photograph) can be seen here crossing in front of the Pima Ranch outbuildings in December 1982. (Courtesy Archaeological Consulting Services, Limited.)

As was the case in the Ahwatukee Ranch prior to and during the initial stage of development, friends in their early 20s lived at Pima Ranch in the years immediately preceding development of Mountain Park Ranch. Having the pristine desert all to themselves resulted in a communal lifestyle, many spirited parties, and the adoption of this orphaned javalina named Miss Piggy, which wandered in from the desert and soon took on the role of mascot and domesticated house pet. (Courtesy Kathleen Raife.)

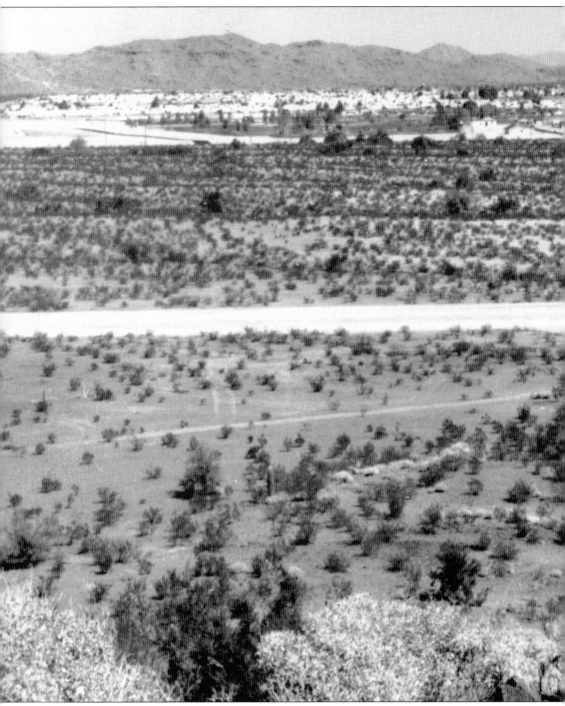

The transition between old and new is captured in this March 1984 photographic overview of Pima Ranch looking north towards Ahwatukee. Groundbreaking on Mountain Park Ranch had just occurred, but the first homeowner wouldn't move into the master-planned community until April 1985. Ray Road (pictured here crossing in front of the ranch's outbuildings) was still dirt but now headed west. Today Sun Ray Park lies just out of the photograph on the left, the Ranch

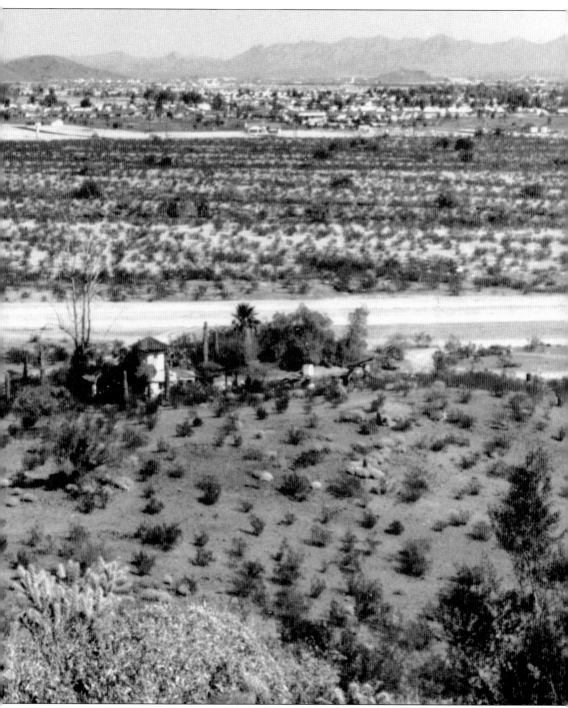

Circle loop crosses Ray Road just out of the photograph on the right, and all of the empty land in between has been developed. The exception remains the hill on which the photograph was taken (foreground), which was to have been the site of William Belden's winter home had plans to build it been implemented over 50 years earlier. (Courtesy Evelyn Dye.)

Infrastructure development during the early years of Mountain Park Ranch is seen above in 1985. The Ranch Circle loop dominates the middle right of the photograph, with the extension of Ray Road (curving horizontally through the loop) begun and creeping toward its eventual connection with Chandler Boulevard. That road still ended at Thirty-second Street and the northwest corner of Lakewood (bottom left). Four years later (below), the Ray-Chandler Loop and Chandler Boulevard's extension into The Foothills was complete, with various subdivisions and Kyrene Monte Vista Elementary School (the light area in the loop at lower left) built around them. The dark areas in both photographs reflect the striking geographic feature from which Mountain Park Ranch takes its name—the mountainous topography at the heart of the community. (Both courtesy Landiscor, Inc.)

Eight

LAKEWOOD

Ironically for land on which two lakes now exist, the Collier-Evans Ranch was situated west of the last farm serviced by the Highline Canal. Relying on well water for its irrigation, the cost of pumping water from the wells had climbed to a prohibitive $22,000 a month by the time the ranch was sold in the mid-1980s. Two historical footnotes involving the ranch live on: Dick Evans's grandfather was one Wilford T. Hayden, the first homesteader on what became Scottsdale's Hayden Road, which is why the street is named for him. And during the 1950s, Ira Fulton, founder of the home-building company that bears his name and one of the country's leading philanthropists, counted the ranch among the customers on his *Arizona Republic* newspaper delivery route in the Kyrene farming community. Today with its signature water, circular parkway, and central greenbelt, Lakewood is a community with a self-contained look and feel that distinguishes it from the surrounding developments.

Texas native Bill Collier's first job in Arizona was washing windows at the San Marcos Hotel in 1917. In 1939, he leased and subsequently purchased one square mile of land on West Chandler Road between what is now Fortieth and Thirty-second Streets for $40 an acre. Collier cleared the raw desert by hand and began growing cotton, barley, and alfalfa. In this early 1940s photograph, Collier stands in the doorway of his house on West Chandler Road. (Courtesy Evans family.)

The Highline Canal ended at Fortieth Street, so to get water on his land Collier had to dig wells. Because the land had a 25-foot downward slope from West Chandler to Pecos Roads, water had to be pumped uphill for irrigation. Bill and wife, Carrie, watch water flow for the first time on the future Lakewood, c. 1940, as one of an eventual five wells gushes at the rate of 2,000 gallons per minute into an irrigation ditch. (Courtesy Evans family.)

Dick Evans married Bill Collier's daughter Helen when he was discharged from the U. S. Navy after World War II. He joined Collier in 1949 and the Collier-Evans Ranch was born. The Collier-Evans' farming operations ultimately encompassed 1,600 acres of leased farmland on the Gila River Indian Reservation between the Forty-eighth and Thirty-second Street alignments. Here Evans keeps the birds at bay in a cornfield on the Collier-Evans Ranch in 1951. (Courtesy Evans family.)

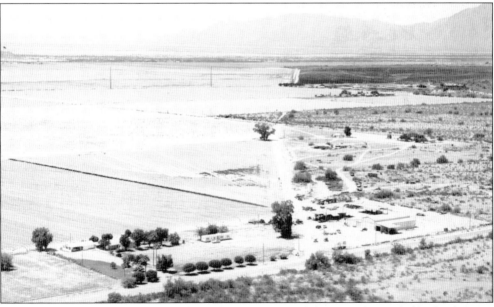

Williams Field Road (foreground) dead-ended at Thirty-second Street until extended by development in the mid-1980s. This 1983 view of the northwest corner of the Collier-Evans Ranch looks southwest over the Collier house (surrounded by trees at lower left), the ranch's repair shop (the building at lower right), and workers' living quarters (near the shop). In the distance lies the Goldman Dairy and, beyond that, the Gila River Indian Reservation and Estrella Mountains. (Courtesy Evans family.)

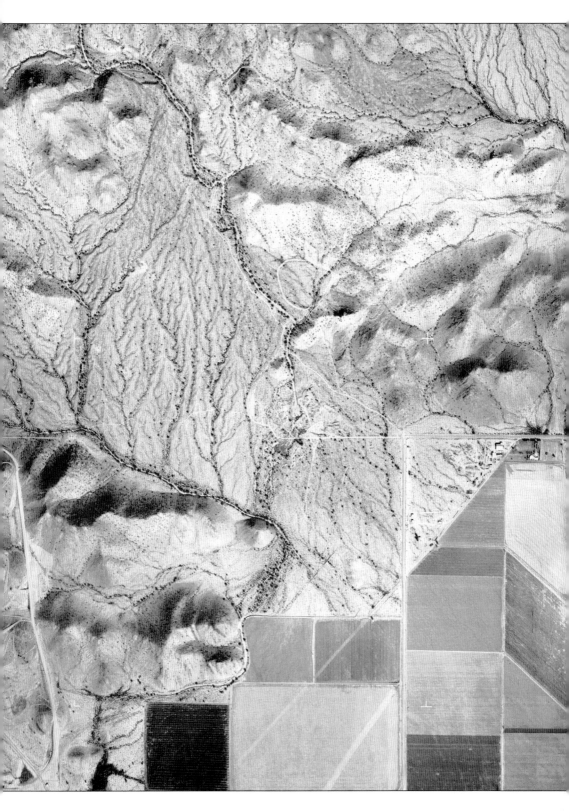

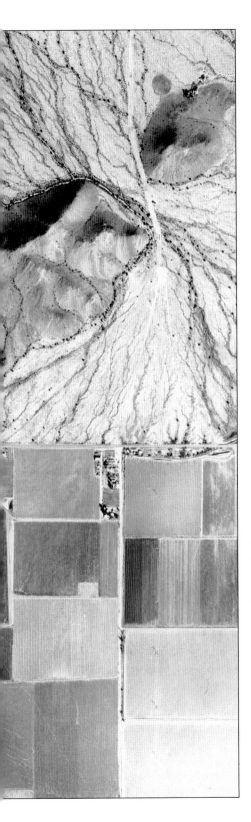

The Collier-Evans Ranch and its surroundings are captured in this 1964 aerial photograph. The one square mile of farmland that would become Lakewood (lower middle of photograph) was fed by five wells, since the Highline Canal ended at the Fortieth Street alignment (extreme right of the photograph). In keeping with the entire area's "high ground" designation, the farmland sloped gradually away from South Mountain, creating a 25-foot drop between Williams Field Road (top of the square) and Pecos Road (bottom, out of photograph). The ranch is bordered on its west by Thirty-second Street (left of the square) and on its east by Fortieth Street, which then was little more than a dirt road between the ranch and its eastern neighbor, Krepela's Dairy. The site of the proposed San Marcos-In-The-Desert resort (chapter three) lies just northwest and west of the ranch. (Courtesy Evans family.)

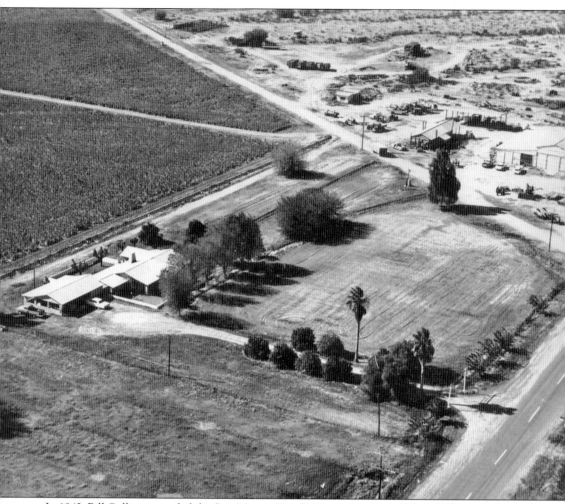

In 1942, Bill Collier expanded the San Marcos Hotel's Desert Inn (page 32) on Williams Field Road, converting it to his family residence. The street's name had been changed from West Chandler Boulevard during World War II. The building's original chimney can be seen protruding from the roof at left in this 1966 photograph. Note the two tall palm trees adjacent the driveway just off of Williams Field Road. Today they stand guard over the parking lot of the Family of Christ Lutheran Church and Learning Center at 3501 Chandler Boulevard. (Courtesy Evans family.)

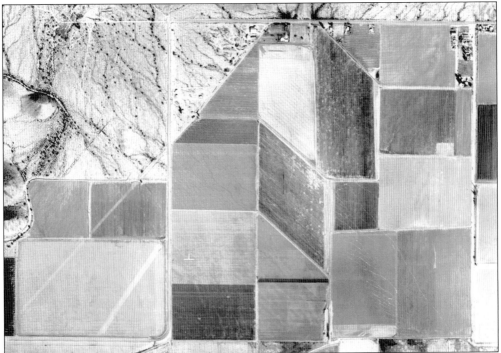

These two photographs illustrate the dramatic before-and-after contrast between the Kyrene farming community as reflected by the Collier-Evans Ranch and of Ahwatukee Foothills as reflected by Lakewood. Pictured above in 1964, the ranch was home to the last farm at the time west of Interstate 10. When groundbreaking on Lakewood occurred in 1985, the first construction was of its two signature lakes. Bill Collier's house, the former Desert Inn, is at the top of both photographs. (Courtesy Evans family.)

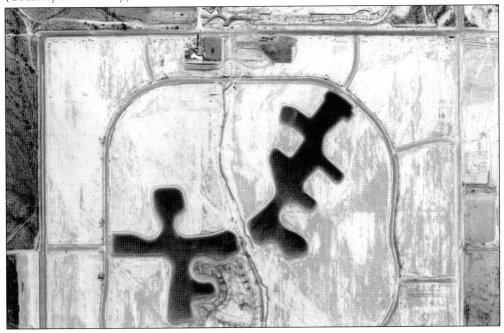

Lakewood's first homeowners arrived in June 1986. The top photograph preserves their view looking northwest across Bassmaster Lake (left on the preceding page), while the bottom photograph offers the same vantage point two years later. A footnote to Lakewood history involves the 1990 Bill Murray film *What About Bob?*, in which a house explodes at the end of the movie. During a period of slow sales in the housing market during the late 1980s, a crew set up camp in Lakewood to film the movie's ending. Using the wooden frame of a house on which construction had been halted, the crew built a finished-house facade on the frame and, with permission from the developer, blew the house up as the cameras rolled. (Both courtesy Cooper family.)

Christmas trees in Ahwatukee Foothills? As farms gave way to residential and commercial development in the mid-1980s, crops shifted from traditional ones like cotton, alfalfa, and barley to, at least in one case, Christmas trees. Cotton had been the cash crop of choice in the Kyrene farming community, but in the late 1980s, Dick Evan's son, Rick, grew and sold Elderica pines, a fast-growing and hardy Christmas tree, on part of the 40 acres the family owned on the northeast corner of Forty-eighth Street and Chandler Boulevard. The Lakewood-sparked agricultural evolution is illustrated above, as Bill Collier gets ready to make a trip to the cotton gin in the late 1960s. Below, Rick Evans stands with one of his Christmas trees in December 1988. (Above courtesy Evans family; below courtesy Rick Evans.)

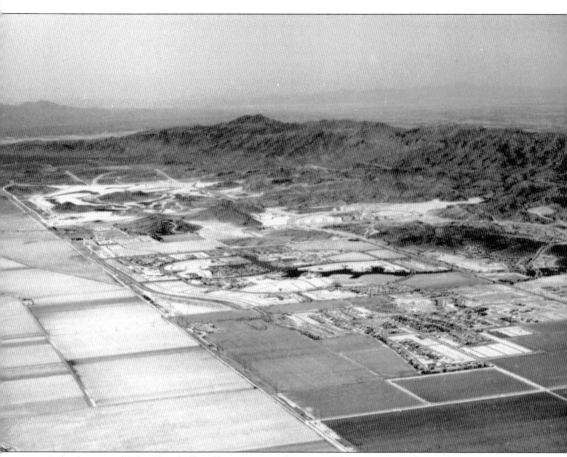

A look toward The Foothills offers a view of parts of three master-planned communities as development pushed west in 1987. Lakewood (the square in center of photograph) was still in its early stages of development with the one square mile that had been the Collier-Evans Ranch retaining little evidence of its agricultural past. Other farmland remains in the foreground, as development meets agriculture near Mountain Park Ranch's southern border of Chandler Boulevard (middle right, running along Lakewood's northern border). In the distance, west of Lakewood, construction of the Foothills golf course proceeds before any houses were built around it. Owing to the impending development of all three communities, Chandler Boulevard and Ray Road have been extended and looped together (middle of photograph). South of Pecos Road (running diagonally at left), land that had been farmed for years reverts back to its native desert condition on the Gila River Indian Reservation. (Courtesy Jim Spadafore.)

Nine

THE FOOTHILLS
AND CLUB WEST

Were it not for International Harvester Company's proving grounds paving the way, roads and subdivisions high up into the foothills of South Mountain would never have been allowed by the city of Phoenix. Thus a visible connectivity exists between the old proving grounds and the master-planned communities that have taken its place. The area's colorful history includes the rumored presence of speakeasies during Prohibition and at least one mineral rights claim staked by Kyrene farming community member Leslie "Tiny" Hunter in 1952. The results of his mining efforts are unknown, but what is known is that the sale of the 4,140-acre property by International Harvester to Burns International in the early 1980s was, at the time, the biggest land transaction between one buyer and one seller in Phoenix history. One other point of connectivity can be found at The Foothills Golf Club—all of the hills, mounds and angulations of the golf course were created with dirt taken from Harvester's elevated airplane landing strip.

International Harvester Company's Phoenix Proving Grounds were established in 1946 on a six-and-a-half-square-mile tract of isolated desert west of the Kyrene farming community, in the heart of what would later become The Foothills and Club West. The communities' main roads were constructed over the proving ground's seven-and-a-quarter-mile and four-mile test tracks (left and right, respectively), both unpaved in this 1953 photograph. (Courtesy Wisconsin Historical Society, WHi39937.)

Looking southeast in 1953, toward the Estrella Mountains, heavily laden International Harvester trucks mount a nine percent grade toward the highest point on the company's seven-and-a-quarter-mile, now-paved test track at the northernmost part of the facility. The steep grade up "The Nine" forced drivers to put the trucks through all gear ratios to negotiate the long slope upward. (Courtesy Wisconsin Historical Society, WHi39933.)

Trucks descend The Nine at the northernmost part of what is now Desert Foothills Parkway. Tragically a visitor was killed in a head-on collision at the top of The Nine on the last day of proving-grounds operations in the mid-1980s, when he ignored multiple warning signs and drove counter-clockwise on the test track directly into an oncoming test truck. (Courtesy Wisconsin Historical Society, WHi39926.)

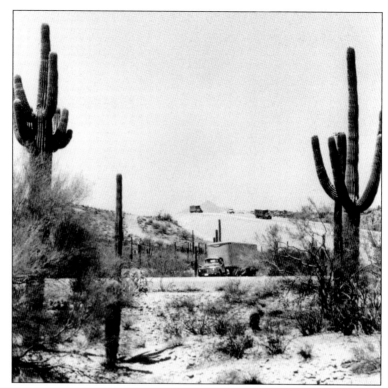

The proving grounds was initially used by General Motors to test the durability of air filters and moving parts in its tanks being used by the United States Army in Northern Africa during World War II. The remote area's extreme heat, rocky ground, and ever-present abrasive dust simulated the conditions found overseas. Here International Harvester puts one of its light-duty trucks through its paces on the proving grounds in the early 1950s. (Courtesy Wisconsin Historical Society, WHi39923.)

From a perch high atop a hill in 1953, the operator of a Harvester TD-24 crawler tractor has an unobstructed view of International Harvester's proving grounds and the land for miles beyond. Years later, uninterrupted topographic vistas such as this would help give The Foothills and Club West master-planned communities their unique appeal. (Courtesy Wisconsin Historical Society, WHi39935.)

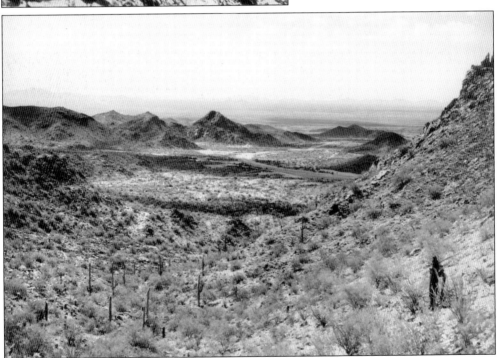

Viewed in 1953 looking southeast from the serenity of South Mountain's Telegraph Pass, the controlled chaos on the proving grounds below is muted in the distance. At right center of the photograph is International Harvester's seven-and-a-quarter-mile paved test track, the future Desert Foothills Parkway, curving south toward what would one day became the heart of The Foothills. (Courtesy Wisconsin Historical Society, WHi39918.)

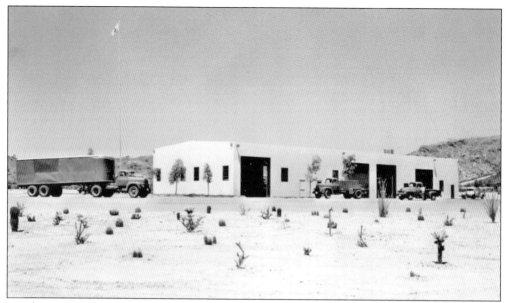

Headquarters for International Harvester's truck-testing operations was this 9,000-square-foot maintenance facility, seen here in the early 1950s. The building was situated just inside the proving grounds entrance near the eventual northwest corner of Twenty-Fourth Street and Pecos Roads. The land at the former entrance site is now part of the Arizona Department of Transportation's 700-foot-wide corridor, set aside as a freeway on-and-off-ramp right-of-way. (Courtesy Wisconsin Historical Society, No. 39930.)

A short distance from the truck building was Harvester's humidity chamber. Inside, a constant 99 percent humidity was maintained to accelerate the rusting and testing of mechanical parts. Understandably Harvester workers considered a stint in the building to be a tough assignment, as the discomfort of the extreme Sonoron Desert temperatures paled in comparison to that of the building's humidity-enhanced interior. (Courtesy Jack Owens.)

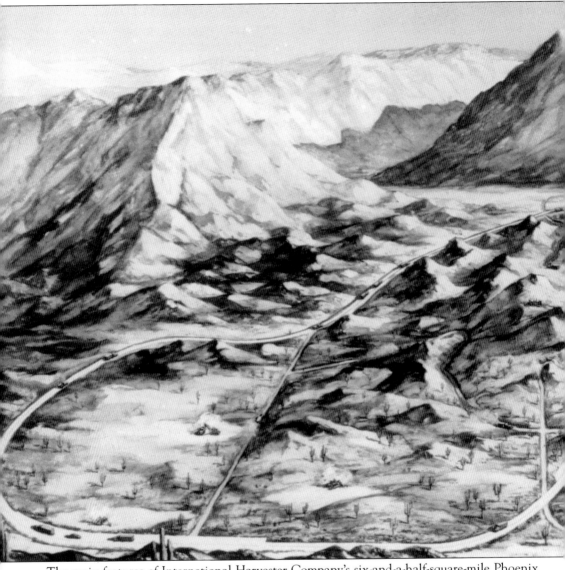

The main features of International Harvester Company's six-and-a-half-square-mile Phoenix Proving Grounds are depicted in an artist's 1953 drawing. At left is the seven-and-a-quarter-mile paved test track, the longest in the country, around which Harvester's test fleet always drove in a clockwise direction. At lower left, trucks are seen on a mile-and-an-eighth "dead flat," with others mounting the nine percent grade at the north end of the loop. A four-mile dirt test track

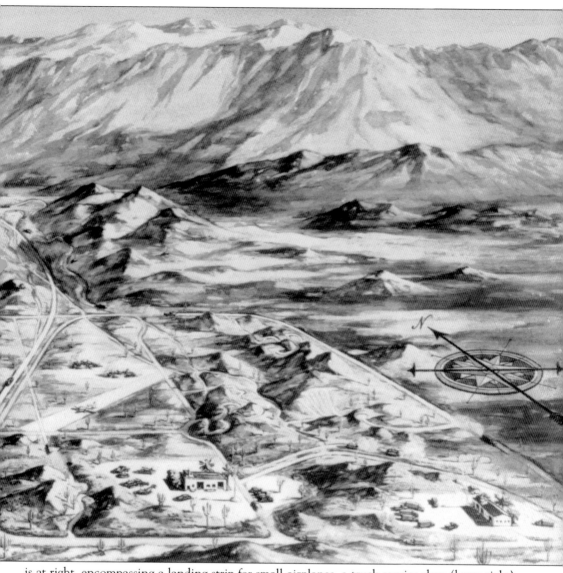

is at right, encompassing a landing strip for small airplanes, a truck service shop (lower right), and a heavy equipment building (left of that). North of the buildings are a series of 20 to 60 percent inclines for special climbing tests. Today the main roads of The Foothills and Club West, clockwise from right, Twenty-fourth Street, Pecos Road, Desert Foothills Parkway, and East Chandler Boulevard, follow the path of both test tracks almost exactly. (Courtesy Wisconsin Historical Society, WHi39993.)

A number of petroglyph sites were located within the proving grounds' six and a half square miles. The giant "Picture Rock" was found just inside the northeast portion of the large paved test track. Here Harvestor surveyor Dale Milner, standing six feet, four inches tall, admires the rock in its natural setting in 1953. The Picture Rock was later moved adjacent to The Foothills Information Center and golf course clubhouse, where it can be found today. (Courtesy Wisconsin Historical Society, WHi39921.)

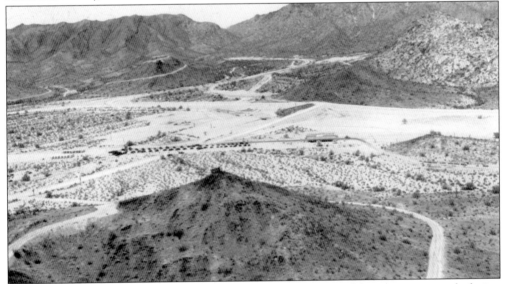

This photograph provides an informative overview of a portion of the proving grounds during International Harvester's 1954 Industrial Power Round-Up, an industry demonstration and sales event. Looking northwest over what is now The Foothills Golf Club, buses and heavy equipment are lined up on part of Harvester's dirt airstrip (center), while in the distance, in the clearing crossing the upper third of the photograph, lies what would eventually become East Chandler Boulevard. (Courtesy Wisconsin Historical Society, WHi39944.)

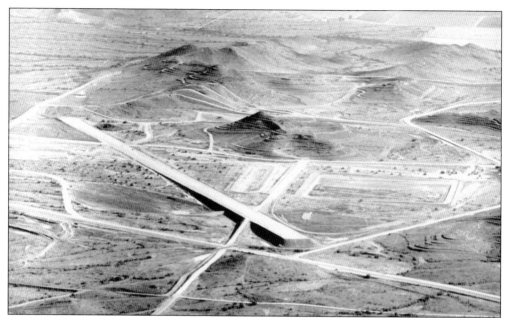

Striking in its symmetry amidst the random scarring of the surrounding desert, Harvester's mile-long, elevated, dirt landing strip was built to fly in company executives and selected customers. In this view looking east, the runway and the land around it are the future site of The Foothills Golf Club and its surrounding neighborhoods. At left is the footprint of Chandler Boulevard, and crossing the lower part of the photograph in front of the landing strip is the future Desert Foothills Parkway. (Courtesy Wisconsin Historical Society, WHi39946.)

Off in the distance, trucks strain to complete their long, slow climb up The Nine, seen here in this picturesque northwestern view. Today all of the land in the foreground has been developed, but The Foothills and Club West have managed to retain much of the peaceful serenity captured in this 1953 photograph. (Courtesy Wisconsin Historical Society, WHi39917.)

A strong back and consistently good sense of humor were two assets on the proving grounds. As in other companies, unique and memorable characters worked at Harvester, enlivening what was otherwise a hot, dusty, and isolated workplace. Lowell "Cowboy" Burton, seen at left with coworker Jack Owens in June 1964, had been a professional wrestler before he started test-driving light-duty trucks on International Harvester's two-mile, high-speed test track. The 300-pound Burton was a proving-grounds legend for his ability to unload 400-pound, 55-gallon, liquid-filled steel drums, unassisted, from the back of trucks. Below, the workers, to whom the difficult task of excavating some sun-baked desert so that a gasoline pipeline could be extended, left their mark on the project in the summer of 1961. (Both courtesy Jack Owens.)

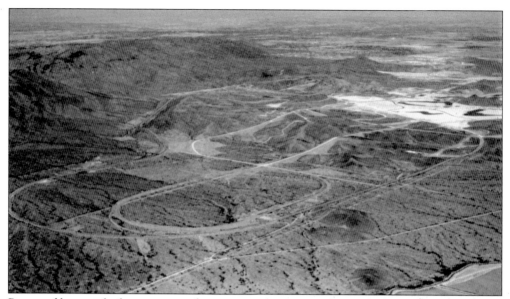

Prompted by an eight-figure patent-infringement judgment award to rival John Deere, International Harvester Company sold its 4,140-acre Phoenix Proving Grounds to Phoenix developer Burns International Corporation in 1983. Burns subsequently formed a joint-venture partnership with Del Webb Corporation. This 1987 aerial photograph, looking northeast toward Ahwatukee in the far distance, shows the infrastructure and golf course development (far right) that preceded home construction in The Foothills and Club West. (Courtesy Jim Spadafore.)

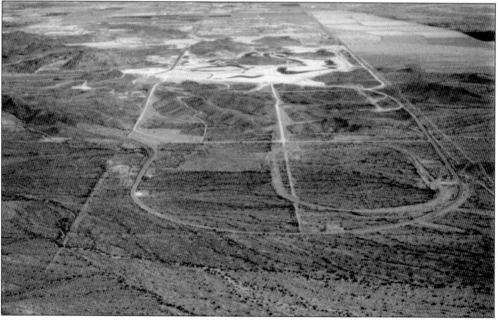

It's a footnote in history, but at one time, the land immediately west of the proving grounds was considered for a prison site. In 1973, the Arizona legislature appropriated $5 million for the construction of an Arizona correctional facility on 320 acres of state land bordering the western boundary of the Harvester property. The land, now part of the South Mountain 640, is seen in the foreground of this 1987 photograph taken after Harvester sold its property. (Courtesy Jim Spadafore.)

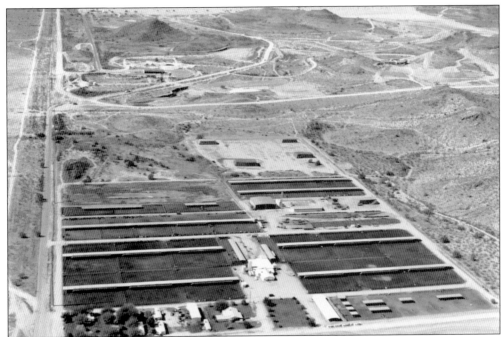

Viewed from its eastern border, International Harvester Company's proving grounds was the next-door neighbor to the Goldman Dairy at the time of this photograph in 1983. Today's Twenty-fourth Street (the curved dirt road crossing the upper middle of the photograph from the right) and Pecos Road (at left top to bottom) follow the alignment of Harvester's four-mile dirt test track and delineate the eastern and southern borders, respectively, of The Foothills. (Courtesy Jim Goldman.)

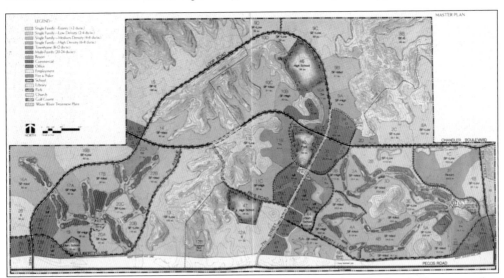

Following the path of the proving ground's two main test tracks, The Foothills master plan contained three phases of development. The Foothills Golf Club and a proposed resort in the hills adjacent to Twenty-fourth Street and Chandler Boulevard were part of Phase 1, with the area north of that designated as Phase 2. In 1990, UDC Homes purchased the 1,000 acres that were to have been Phase 3, on which it developed the master-planned community of Club West. (Courtesy Chad Chadderton.)

122

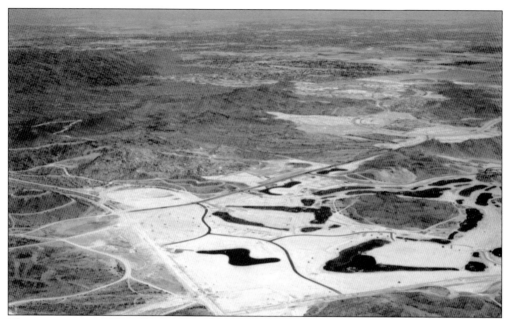

The intersection of Chandler Boulevard and Desert Foothills Parkway (middle left in photograph) was created by the extension of Chandler Boulevard into The Foothills in 1987. Prior to that, the road ended at Thirty-second Street. The newly designed but not-yet-paved Liberty Lane, The Foothills golf course, and future home of the Ahwatukee Foothills YMCA are seen in the lower right of the photograph. (Courtesy Jim Spadafore.)

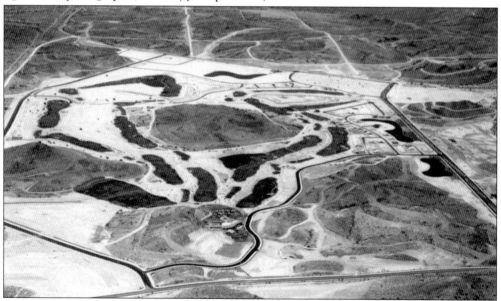

Looking west over Twenty-fourth Street, The Foothills Information Center and golf clubhouse (lower middle of photograph) sits all by itself on newly constructed Clubhouse Drive in 1987. As in Ahwatukee 14 years earlier, the 180-acre Foothills Golf Club was the first item of construction by the Burns-Del Webb partnership. It opened for play on Christmas Day 1987. Home construction began a month later, and the first homeowner moved into The Foothills in July 1988. (Courtesy Jim Spadafore.)

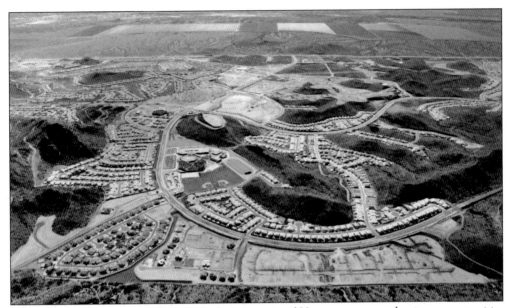

The roads already carved into the hillsides by International Harvester presented unique opportunities for development that the city of Phoenix would never have allowed otherwise. The corkscrew-scarred hill on the northwest corner of the intersection of Chandler Boulevard and Desert Foothills Parkway (light circle, left-center of photograph) was lowered by 60 feet in order to create the 12-home Candlewood Estates subdivision. This view from over South Mountain, looking south toward the Gila River Indian Reservation, was taken in 1990. (Courtesy Jim Spadafore.)

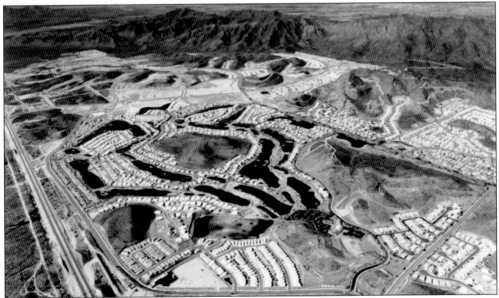

Phoenix's South Mountain rises in the distance in this northwest view in 1990. Neighborhoods were sprouting up around the golf course as Phase I of The Foothills development neared completion. Twenty-fourth Street meets Chandler Boulevard in the extreme right of the photograph. The mountainous topography immediately adjacent the intersection marks the site of a proposed 700-room resort hotel. Marketing research determined that the area was too remote at the time to support such a venture, and the hotel was never built. (Courtesy Jim Spadafore.)

The center median of Chandler Boulevard glimmers with the glow of a million white lights during its Festival of Lights holiday display. This annual tradition, which runs from Thanksgiving weekend through the New Year, was started in 1988 by a Del Web marketing director, who choreographed a lights display on Chandler Boulevard between Twenty-fourth Street and Clubhouse Drive. The display annually draws thousands of admirers to the area. (Courtesy Festival of Lights Committee.)

BIBLIOGRAPHY

Blank-Roper, Laurie, and Richard W. Effland. *Archaeological Investigations at Two Sites Within the Ahwatukee Expansion Area*. Tempe, AZ: Archaeological Consulting Services Limited, January 1981.

Collins, William S.. *The Emerging Metropolis: Phoenix 1944–1973*. Arizona State Parks Board, 2005.

Effland, Richard W. and Margerie Green. *Proposed Ahwatukee Expansion*. Tempe, AZ: Archaeological Consulting Services, Limited, November 1979.

————, and ————. *The Mystic House: Documentation of the Ahwatukee Ranch and The Slawson Home*. Tempe, AZ: Archaeological Consulting Services Limited, July 1981.

Furlong, Ben. *The Story of Kyrene*. Kyrene School District, 1992.

Gammage, Grady Jr., *Phoenix In Perspective*, Arizona Board of Regents, for and on behalf of Arizona State University, and its College of Architecture and Environmental Design, Herberger Center for Design Excellence, 1999.

Green, Margerie, *A National Register Evaluation of Camp Ocatillo and Pima Ranch*. Archaeological Consulting Services Limited, January 1983.

Green, Margerie, *Archaeological Test Investigations at Pima Ranch*. Tempe, AZ: Archaeological Consulting Services Limited, May 1983.

Green, Margerie and Richard W. Effland, *Archaeological Investigations at the Pecos Ranch Development Property*. Tempe, AZ: Archaeological Consulting Services, Limited, May 1984.

Its history grand but its days numbered, the Ahwatukee ranch house stands guard during the early days of Ahwatukee's development. Looking northeast from the house in 1973 toward Interstate 10 and the first homes in the master-planned development, the ranch from which the community takes its name stood proudly for over 50 years. Through the Ames and Brinton ownerships, with Byron Slawson the constant throughout, the ranch marked a time now long gone when large tracts of open desert in close proximity to Phoenix could be purchased and used to build extravagant winter homes. The ranch house, the first and once the only non-homesteaded residence in the future Village of Ahwatukee Foothills, was torn down in 1975. With that, one era ended as another began. (Courtesy Robert Peshall.)

ACROSS AMERICA, PEOPLE ARE DISCOVERING SOMETHING WONDERFUL. THEIR HERITAGE.

Arcadia Publishing is the leading local history publisher in the United States. With more than 3,000 titles in print and hundreds of new titles released every year, Arcadia has extensive specialized experience chronicling the history of communities and celebrating America's hidden stories, bringing to life the people, places, and events from the past. To discover the history of other communities across the nation, please visit:

www.arcadiapublishing.com

Customized search tools allow you to find regional history books about the town where you grew up, the cities where your friends and family live, the town where your parents met, or even that retirement spot you've been dreaming about.